WARHOL
MAKOS

WARHOL
MAKOS

A personal photographic memoir

NAL BOOKS

NEW AMERICAN LIBRARY

NEW YORK

B
Warhol

DESIGN: VINCENT McEVOY, CHRISTOPHER MAKOS

CONTRIBUTORS: HENRY GELDZAHLER, GLENN ALBIN

SPECIAL THANKS:
KEN LELAND, SHEA METCALF
DREW HOLBROOK, CHRIS HANLEY, DOTSON RADER
ESTHER MITGANG, VINCENTE CARRENTON
FRED HUGHES, GERALD ROTHBERG
SPENCER BECK, CAT LEDGER
ANTHONY D'OFFAY, RON FELDMAN
JEAN JAQUES NUDET, HERMANN WUNSCHE
PILAR VICO, AURELIO TORRENTE
VINCENT McEVOY, PETER WISE
TONY AND DIANA

First published in England by W. H. Allen & Co. Plc.

 NAL BOOKS TRADEMARK REG. U.S. PAT. OFF. AND FOREIGN COUNTRIES
REGISTERED TRADEMARK—MARCA REGISTRADA
HECHO EN DRESDEN, TN, USA

SIGNET, SIGNET CLASSIC, MENTOR, ONYX, PLUME, MERIDIAN
and NAL BOOKS are published by NAL PENGUIN INC.,
1633 Broadway, New York, New York 10019

First Printing, March, 1989

1 2 3 4 5 6 7 8 9

PRINTED IN THE UNITED STATES OF AMERICA

CONTENTS

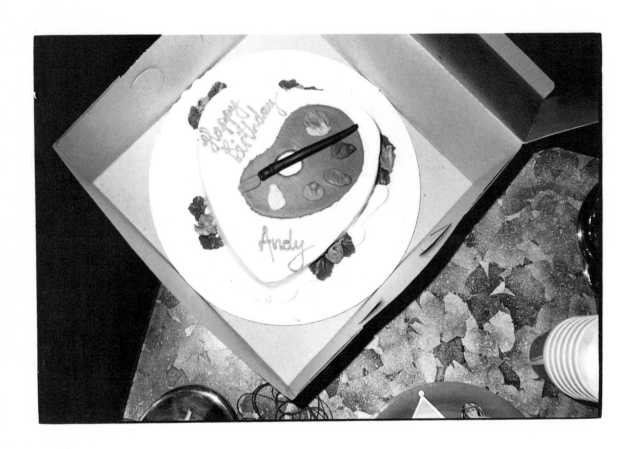

At home on 66th Street, with Andy's birthday cake on his eggshell table. (8 August 1983)

For Andy, who taught me how to see.

AT FIRST I FOUND SOMETHING DISTURBING ABOUT CHRIS Makos' book: it is about 'his' Andy. I quickly realized that this is due to the fact that it deals exclusively with Andy's last years, a period in which I played no role. *Warhol by Makos* is a personal view — and an intimate one — of Mr Mystery himself. It is an authentic portrait of Andy of the thousand faces; it would be odd indeed if it were consonant with my own memories of several decades ago. During the last 20 years my role was mostly one that consisted in cheering from the sidelines, while it was another crew that swept in and around the brilliant black sun that was Andy's aura.

There is always a lot of talk about the various decades: 'What were the sixties like?' and so on. I realize now, having lived long enough to have spanned a few decades myself, that I don't set things comfortably in 'their' decade. I have to wrench my brain about to think about the sixties or the fifties or, for that matter, the seventies. As for the eighties — forget about it. It all seems to be one long tunnel that stretches back to early memories and from there forwards to today: time that is lived through resists categorization.

For Chris Makos it is Andy the star, Andy the inheritor of the Hollywood of his own youth, who lies behind so many of these photographs. Paul Morrissey used to point out that every Hollywood mogul, in the time of the big studios, always had one or two more stars under contract than could be used in any given season, as this encouraged them to scrap among themselves for his attention and his approval. This accounts for some of the fun and tension in Chris' photographs. And then, too, on the visits to places like China and Colorado pictured here, where Andy doesn't fit the local stereotypes, he seems less reluctant to play camp or act the *ingénue*. Andy out of context feels a need to be the star not only for the official portrait commissions, but in his *own* scene, the caravan that moves him and his sensibility from place to place. Andy always felt great curiosity about the world out there. When I met Andy in 1960 he had just come back from a trip round the world. What did you like best I asked. 'Oh, he said, Cairo — the airport!' It was in this conversation, too, that he teased me for my academic approach to such things as geography and history: 'Oh! Teach me a new fact every day and then I'll be smart.'

Mugging or deadpan, teasing or hiding — Andy was a complex figure, enormously resistant to analysis and impossible to categorize. It is a great asset in Chris Makos' photographs that they reveal in many instances new and unfamiliar faces of the legendary pop figure Andy Warhol.

HENRY GELDZAHLER, SOUTHAMPTON, N.Y. 1987

ANDY WARHOL WAS LIKE A BROTHER TO CHRISTOPHER Makos. The friendship between the two was that of a pair of innocents who had come to the 'big city' in search of hard experience, of life in the raw. They first met in 1971 in New York, at a retrospective exhibition of Warhol's work at the Whitney Museum, and within a few years they had become virtually inseparable, whether on the fringes of Manhattan's *demi-monde* or on their extensive travels abroad. Warhol was drawn to Makos as to one who shared his own reserve and ingenuousness, while being possessed of a dogged tenacity fostered by the particular urban environment in which they lived. Warhol paid Makos' work what was perhaps his highest compliment: his photographs, Warhol said, were 'modern'.

'Makos uses his camera as a knife,' commented writer Dotson Rader. His observation might equally well have been made in reference to Warhol, whose own innate democratic sensibility ironed out distinctions of class, fame and wealth, and whose art encompassed a diversity of images from those of Mao to those of Elvis, from drag queens to Prince Charles, from Coca-Cola to the electric chair — all presented as equally glamorous and devoid of sexual overtones. Makos' photographs display the same anti-élitism, a ruthlessness in the guise of innocence. With his camera, he approaches a biker in the same way as he does an industrialist: unselfconsciously, voyeuristically and without feeling. He himself is absent. The critical function of artifice is totally ignored. There is nothing to discover behind a subject's gesture, pose or expression: Makos' approach is naked, uncalculating, indeed nihilistic.

At home in his West Village apartment, its walls covered with art inscribed to him by Warhol, Man Ray, Basquiat and Haring, its rooms littered with remote controls, bicycles and paper plates, Makos talks with ease and inspiration of his late friend Warhol. He is amusing in his anecdotes, impatient in his narration, opaque and detached in his descriptions, as though he were recalling someone else's experiences, not his own. Not surprisingly, his tone and even his syntax resemble Warhol's own notorious 'whine'. They were close friends, phone pals and travelling companions. In this biography of Warhol, Makos' personal photographs represent a happy collaboration: camera (Makos) meets photo opportunity (Warhol). This book is a friend's enduring tribute to a relationship that came to an abrupt end with Warhol's untimely death in 1987. And it tells us more than Makos perhaps imagined when he photographed Warhol imitating the ferocious snarl of a stone lion in Peking. This, then, is a collection of glimpses of an extraordinary artist's life, as captured by a fellow artist's extraordinary eye.

GLENN ALBIN 1987

WHEN I WAS A KID GROWING UP IN CALIFORNIA in the 1960s and heard of Andy Warhol, I don't think I was interested as much in him as in all the names associated with him: Joe D'Alessandro, Viva, Ingrid Superstar, Holly Woodlawn. I'd seen photographs of Andy and Edie Sedgwick together with their silver hair, their identical sunglasses and striped shirts, and although they both looked super-cool, I felt drawn more to Edie. I loved the idea of the Factory, where all these people gathered — but I never pictured Andy painting there. To me it was just a great and distant pop circus, somewhere far away. I'd been in New York for some years before I met Andy. By the time I got there, in the mid-seventies, it was a different Factory, with a whole set of new characters, such as Bianca Jagger, Halston, Jed Johnson, Victor Hugo, Bob Colacello, Ronnie Cutrone, Catherine Guinness and Fred Hughes. Fred was Andy's business adviser and was responsible for the 'clean-up' of those associated with Andy, but it was still a very wild time, with Studio 54 and the world that revolved around the kind of night-life there.

THE ANDY SHOW

Andy needed someone who could run the Warhol show for him, someone to be his mouthpiece. What he was looking for was someone who could 'think Andy' and take care of the decision-making. Bob Colacello (editor of *Interview* magazine, 1973-1983), Fred Hughes and I all served Andy in this way. We got him round the world, in and out of book-signings and openings, to and from dinners and parties. Bob's talent with Andy was explaining him to the public so that all Andy had to do was insert an occasional 'Oh, great.' Fred gave Andy invaluable advice on social strategy: he introduced him to the rich and titled, and was responsible for many of the acute business decisions and transactions that made Andy a multi-millionaire, including selling portrait commissions and investing in antiques and real estate. I was the wild one who brought out the kooky side of Andy. I got him

interested in photography, I got him to wear T-shirts and headbands, I got him to dress up in drag for a series of photographs. Andy used to say to me, 'Can I buy your energy?' There was also Paige Powell (*Interview* magazine's advertising manager), who worked with Andy to dazzle advertisers with his appearance in their shops or at luncheons. Andy was close to all of us, and, as happens in the case of so many unattached men in his position, we became his 'family'. Our unconditional devotion to him went far beyond merely serving 'the boss'. He was a friend.

HIS LOOK

It was Andy's look that attracted so many people. When he was younger, he played with the idea of looking older, and when he was older, with that of looking younger. He was peculiar-looking, and whether or not people recognized him as a famous artist, they knew he was someone important. Andy had a tremendous influence on artists' paying as much attention to their appearance as to their work. He made the clothes he wore look original on him by dressing as immaculately as possible and then deliberately twisting his tie askew or undoing one of his collar buttons. His love of trendy things was part of what made him always look so modern. Half of it was loving to have something and wear it before anyone else even knew it existed, and the other half was loving to collect things. When the Swatch watch came out, he wanted to have every model there was; when Rolex made a Mickey Mouse watch, he had one before anyone else. And even though he didn't want to detract from the spirituality of crystals by treating them as a fad, Andy was wearing them before they became something you saw everywhere.

Andy had his best look in 1987, the year he died. He wore black Levi 501s or Verri Uomo, a black Brooks Brothers turtleneck sweater, an L.L. Bean red down vest, a black leather car coat by Stephen Sprouse, white or black Reeboks, a big crystal around his neck and big black-framed glasses, and his hair was 'huge',

jutting out wildly. He was like a cross between Stephen Sprouse and Tina Turner. Andy's look always made a statement, and it was usually about *not* looking perfect. His last look was as chic as ever, although the overall effect had a lot to do with his general aura: it was as though he'd accomplished everything imaginable in his lifetime and it was time to go.

MODELLING

One of the reasons Andy became a model with the Zoli agency in 1983 was that he had simply got tired of everyone asking him to pose for nothing, just because he was Andy Warhol. So he became a model and there he was in the Zoli book, along with all the other male models; he was a Ford model at the end. Another reason was that at the time a model was really the thing to be. One of his first jobs was for the Van Laack shirt company and he was absolutely thrilled when they gave him dozens of their shirts to wear. Then came the offers to do runway modelling, and I immediately thought, 'Oh God, Andy's so stiff. How's he going to manage a runway?' But he did it as himself, as a Warhol-type model would do it: stiffly. Then he began feeling guilty, worrying that the other models would start to hate him because he was taking jobs away from them. But he didn't get very many runway jobs, and in any case the print ads were more like mere endorsements of his celebrity status than anything else.

BEAUTY TIPS

Andy's beauty tips were as follows: get a big bag and fill it up with as many up-market hypo-allergenic cosmetics, skin creams and astringents as possible, and whenever you arrive anywhere, open it up, set up a little altar in front of a mirror and give yourself a treatment. That was what you'd see Andy doing if you walked into his bathroom at a hotel. And it did make him look better. He wasn't insecure about his looks; he knew he had lots of character. I think his interest in beauty care derived from his days as a Zoli model and, particularly, from his fascination with film

14

continued on Page 16

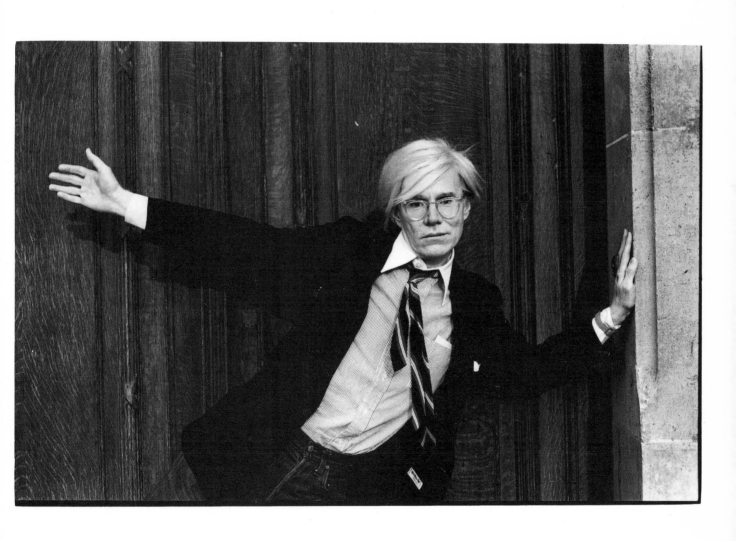

In Paris. The picture used for his memorial card at St Patrick's in New York. (1981)

stars. Andy was the first artist who was really hooked on the film-star look, and being well-groomed was part of it. He wanted to look like a star – and he did.

HIS WIG

I had known Andy for about six years before I realized that he wore a wig. It had never occurred to me. It was so absurd — who would have bothered actually to wear a wig like that? But Andy had 50 of them.

The first time I noticed that Andy wore a wig was when I bought a convertible. He was always resistant to the idea of going for a drive and he'd say, 'Oh, can't you put the top up?' because it was always a struggle for him to keep his 'hat' on. For him it was a personal issue, and I always referred to his 'hat' if we ever needed to talk about it. Andy would put on a baseball cap or a scarf for a car ride, but the wind would invariably gust up and — oops — his 'hat' would still fly back. I would think, 'Poor dear can't keep that thing down.' Whenever we flew to Europe, by the time we got there his 'hat' would have been pushed so far back he'd have to adjust it to get through customs. But people never saw a man and his wig; they saw Andy Warhol.

CASH AND CARRY

I never saw Andy drive; I don't think he had a licence. He never had credit cards; he carried cash. I think he liked it that way, because as a kid he'd never had any money. He didn't carry a wallet, but he always had crisp hundred-dollar notes somewhere on him in a neat brown envelope, and he'd whip them out when he wanted them.

GOSSIP

Andy must have heard more gossip than any other person in art history. He was an expert at getting his friends in Hollywood, Princeton, Newport or the East Village to tell him things they wouldn't tell anyone else. Andy would write his diary over the telephone with Pat Hackett (*Interview* contributing editor since the

magazine's inception), a process which, like a visit to a good hairdresser, took the form of an hour-long gossip session from nine to ten every morning. I'd speak with him much earlier than that, usually by eight o'clock. We'd talk about the night before: Had I met anyone cute or famous? Had I heard any good stories? Basic gossip about the people we knew or wanted to know. Andy lusted after people as well as money; he lifted enormous chunks of other people's personalities and made them his own. He lived a great deal of his life vicariously. His fascination with biographies provided him with another source of 'gossip' that he could use. At cocktail parties he would turn what he had read into gossip: 'Oh, I didn't know Lana Turner was screwing so and so.'

Andy also made what he read part of his own life. Once in a while he'd come up with an amazing story about the old days, when he was in his twenties, and the plot would be just too ingenuous to be true. He told me that he'd once gone round the world with a lover in a TWA Constellation, and he had another story about one of his lovers drowning. I'd say, 'I don't believe that.' And he'd say, 'Oh, maybe that was in the Douglas Fairbanks book.'

FRIENDSHIP

Andy was a very familial person, and he created his family as he went along. Unmarried men often do this. Andy was very paternal, maternal and fraternal with me. He would get involved in his friends' emotional needs, which was another aspect of his vicarious living. But his own emotional needs were overshadowed by his work. He was intensely absorbed in his work — except when he was having a relationship, and then the relationship became his work.

PERSONALITY

Andy liked being non-committal because he thought that was the best way of being diplomatic. He wasn't afraid to say that something was the greatest,

but he didn't like publicly to dislike anything. I don't know when he first started saying, 'Great', but I think that habit had a lot to do with the influence of Bob Colacello. Bob was the ultimate diplomat. And that rubbed off on Andy.

When Andy was in a small group, he was very cohesive and even talkative. But once he was among four or five people, he didn't want to rock the boat. Andy was able to become the important figure he did only with the help of a lot of good friends, especially the art critics and dealers, who took a big chance on him and did most of the talking. Society liked him because he didn't make a lot of noise.

Andy was sometimes stubborn and once he got started he couldn't be budged. If he got into an argument about who had starred in a movie, he'd say, 'No, you're wrong,' and it would go on for days. Then suddenly he would acknowledge that you were right, by saying, 'Oh, yeah, it was Rita Hayworth,' but somehow he'd try to change it round so that you were still wrong.

PRACTICAL ART

Andy's whole career was based on practicality; it was the way he made his paintings and films. His approach was practical because that was the quickest and easiest way to get something done. He hated waste, whether it was of time or of out-of-date stationery.

Andy saved everything, from prints that had slipped while being silk-screened to dead copper batteries. He felt that if there was copper in a dead battery it would someday be valuable, and he was probably right. He was definitely right about the art misprints. His time capsules are filled with junk of this kind, together with fan letters, electricity bills, copies of *People* magazine, unopened gifts, junk mail, *New York Post* covers, shopping bags, and art given to him by fans.

continued on Page 34

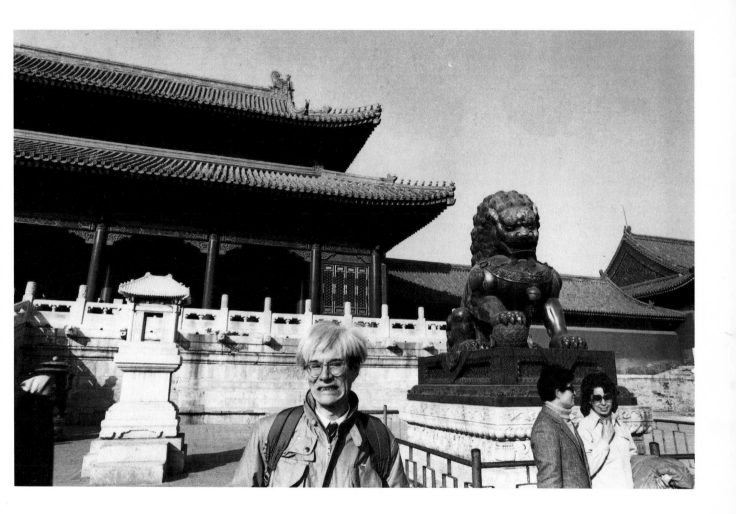

At the Forbidden City in Beijing, mimicking the stone lion. (1982)

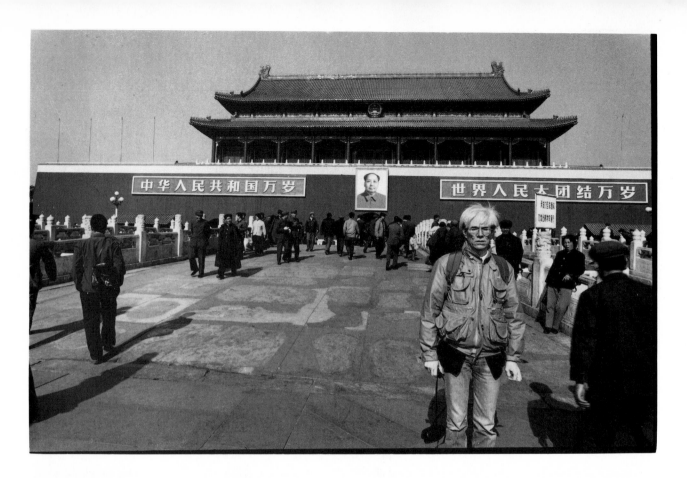

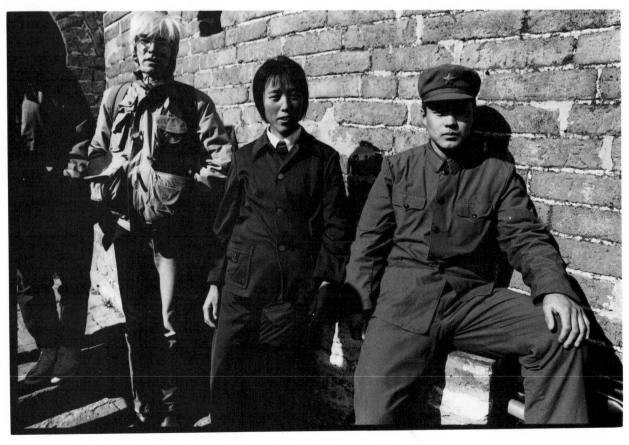

TOP Tienman Square, Beijing. (1982)
BOTTOM Keeping some Red Guards company at the Great Wall. (1982)

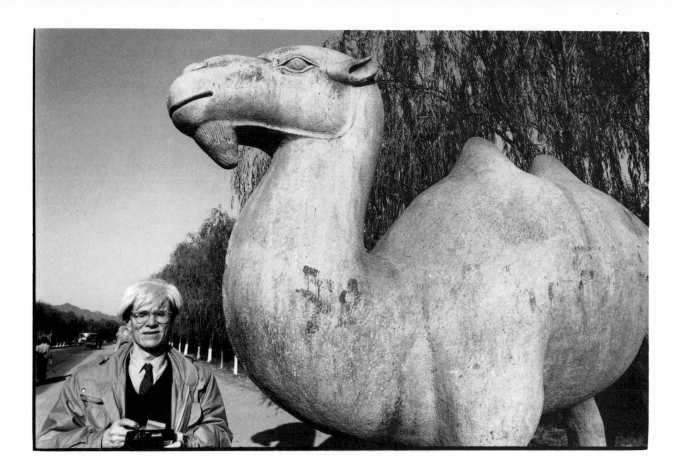

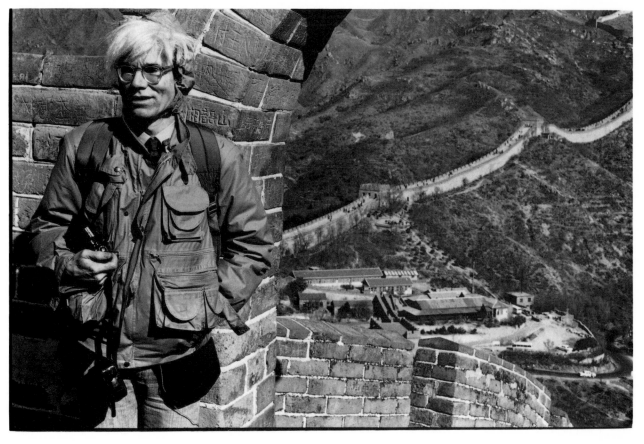

TOP Stopping to mimic the stone camel on the way to the Great Wall. (1982)
BOTTOM At the Great Wall. (1982)

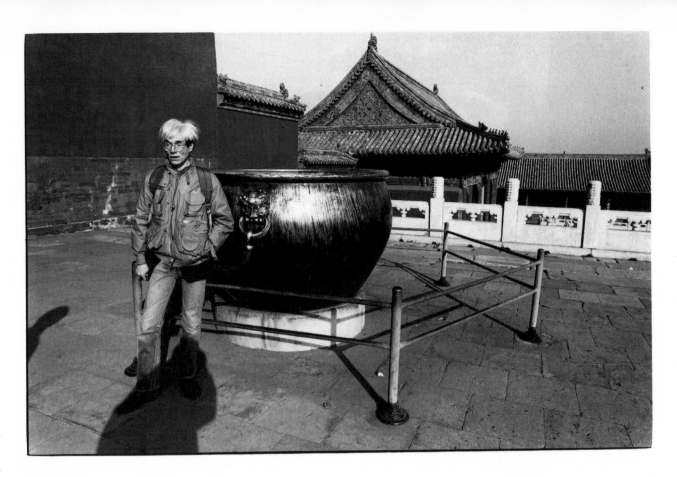

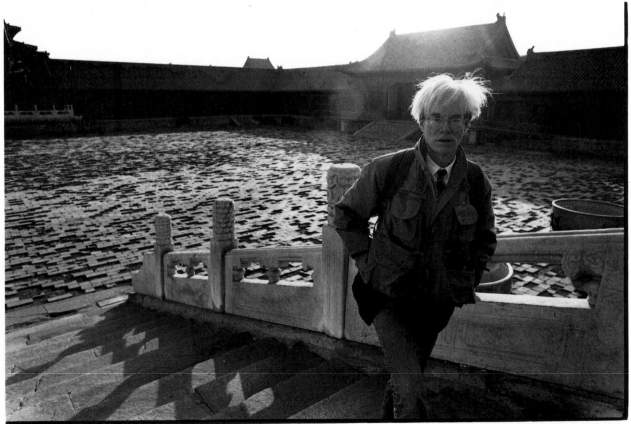

TOP AND BOTTOM Inside the Forbidden City, Beijing. (1982)

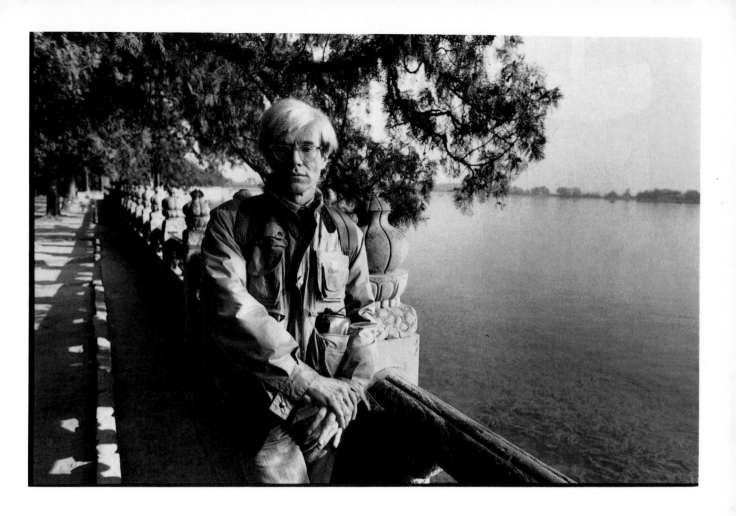

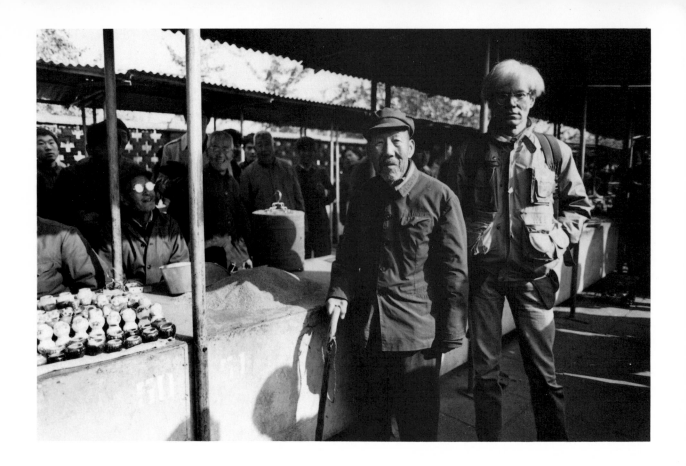

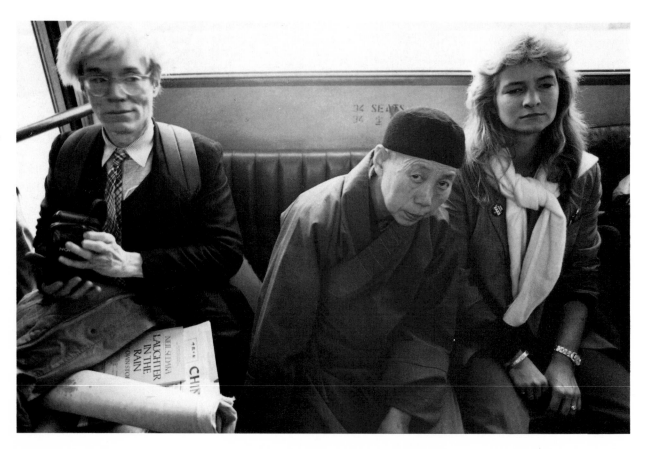

TOP In a street market in Beijing. (1982) BOTTOM On the shuttle bus, on the way from the plane to Chinese customs, with a Chinese lady and Natasha Grenfeld. (1982)

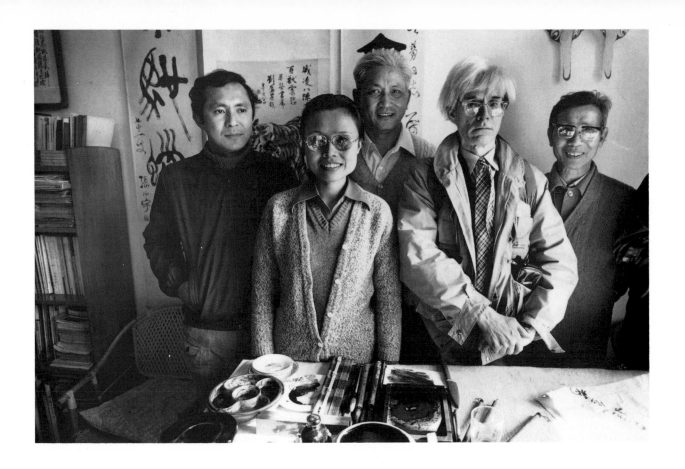

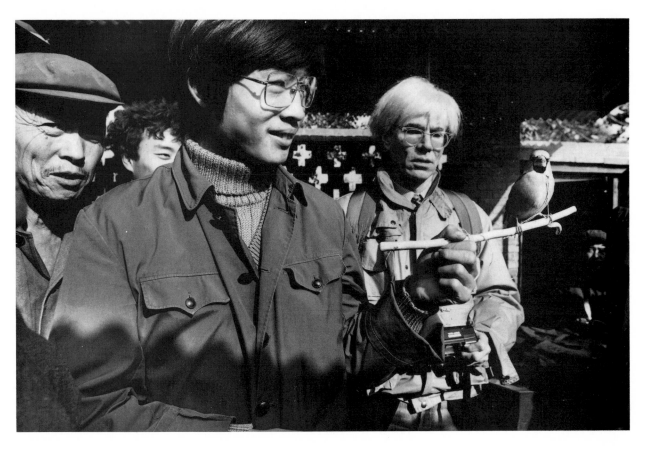

TOP Visiting the home of a calligraphy artist. (1982)
BOTTOM Shopping in the bird market in Beijing. (1982)

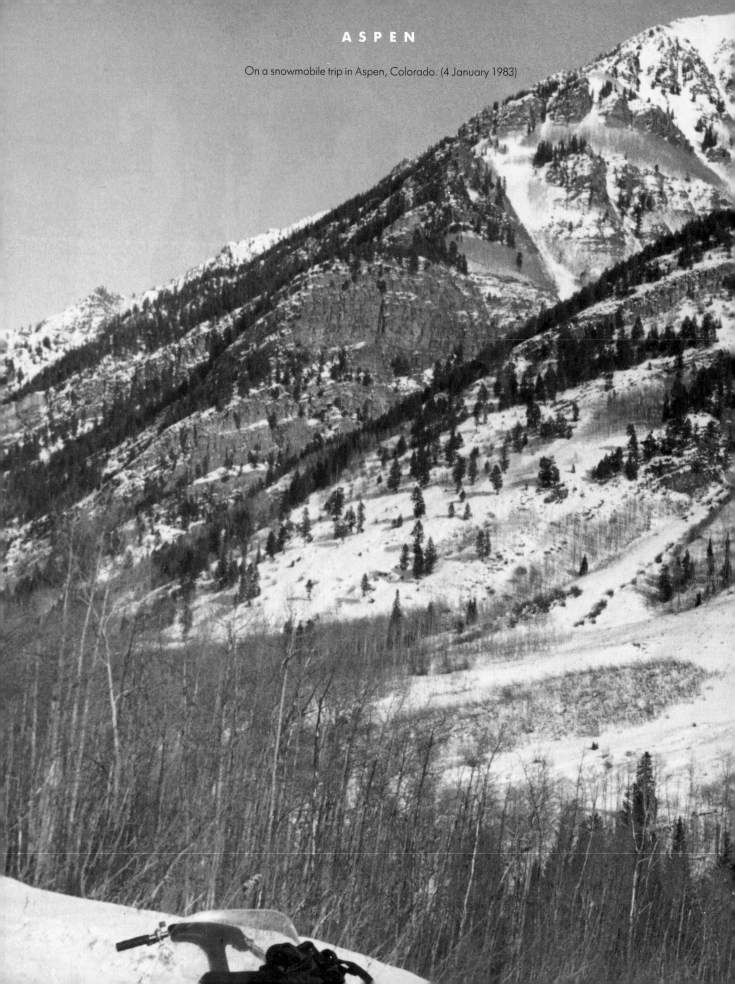

ASPEN

On a snowmobile trip in Aspen, Colorado. (4 January 1983)

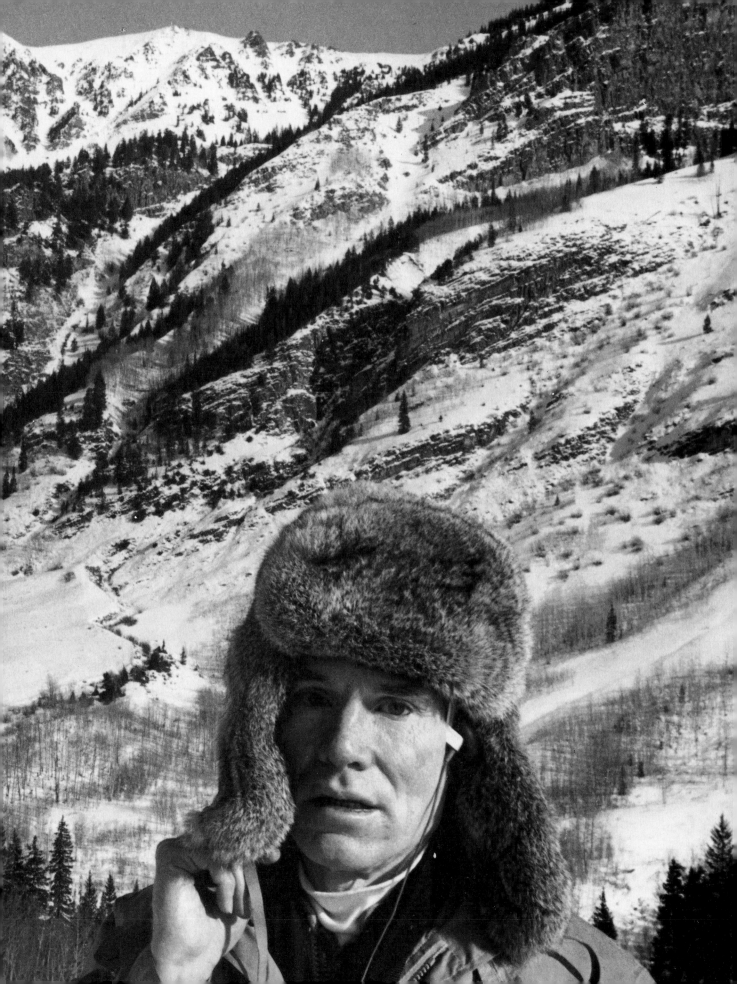

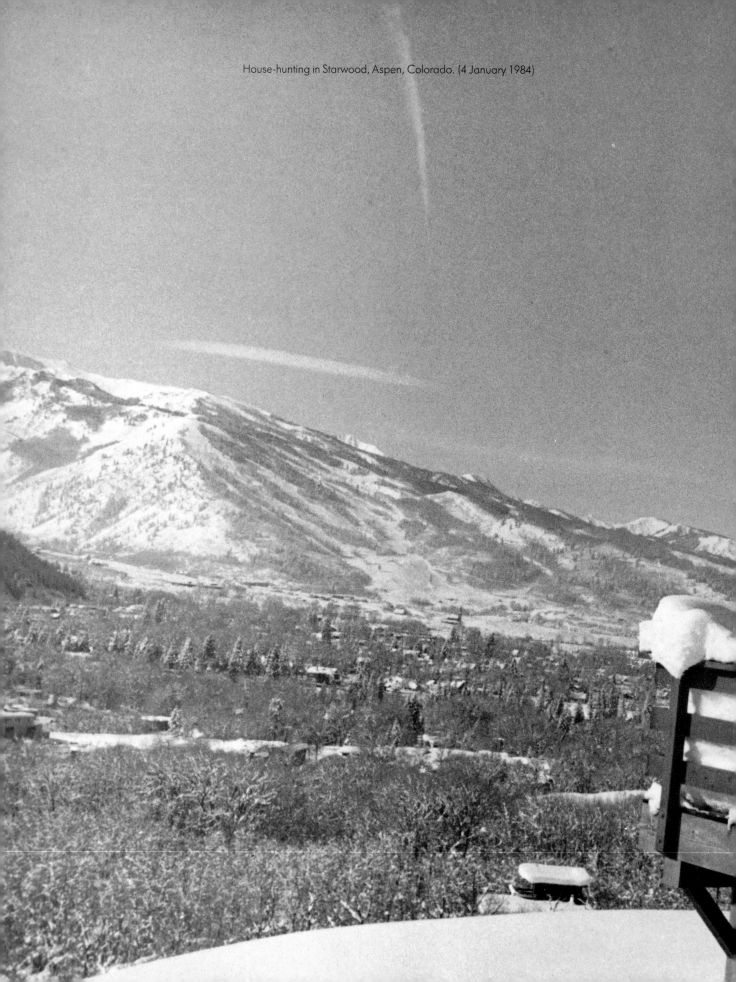

House-hunting in Starwood, Aspen, Colorado. (4 January 1984)

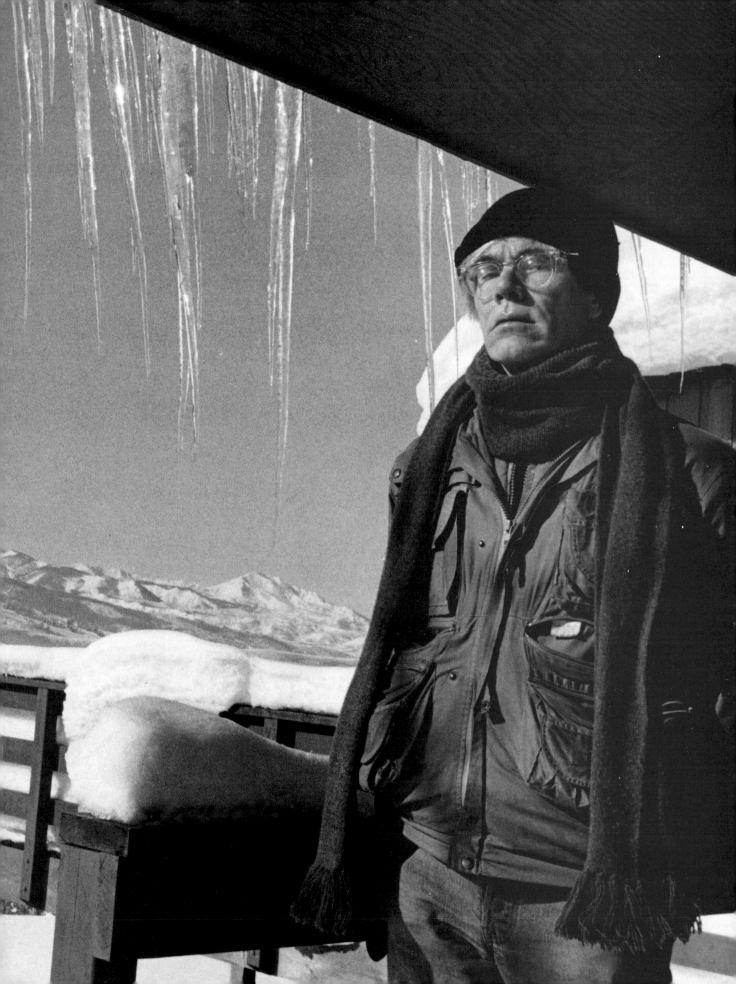

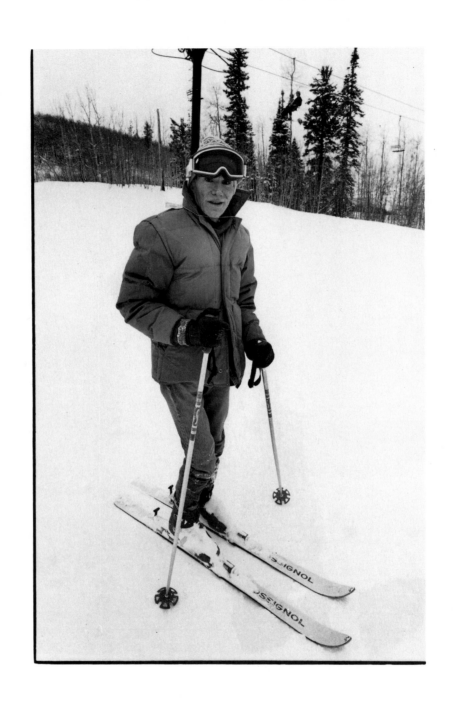

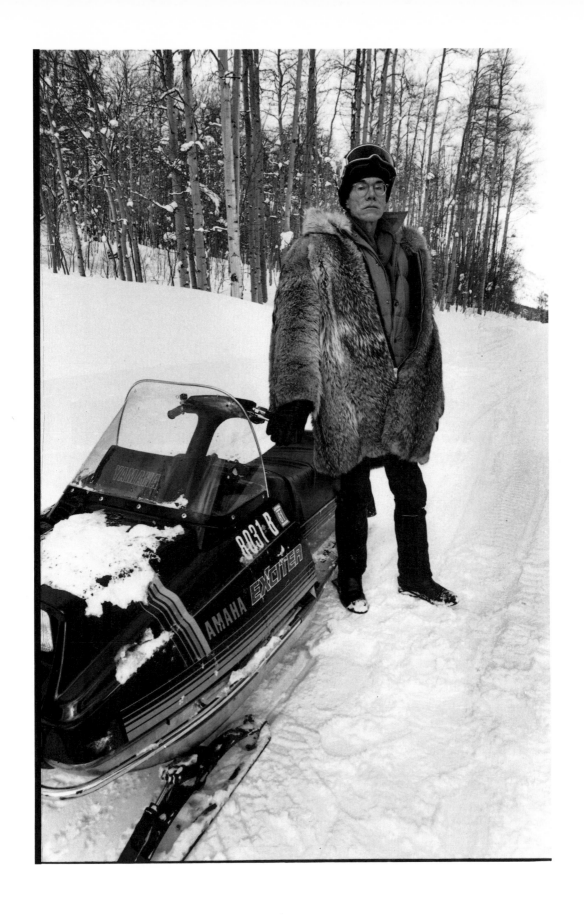

Getting ready to explore the woods in Aspen on Andy's snowmobile. (6 January 1982)

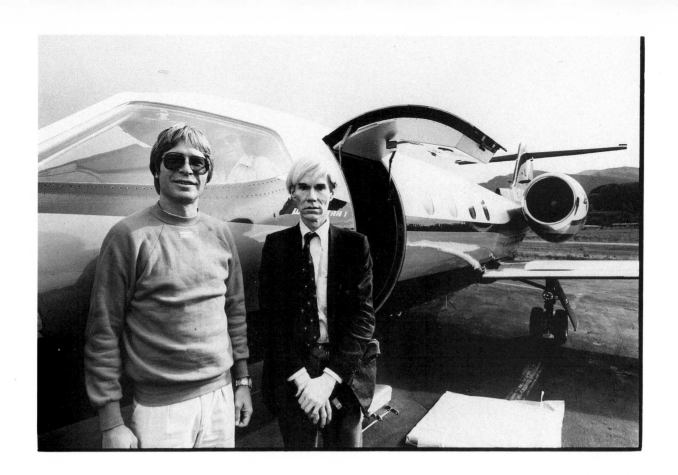

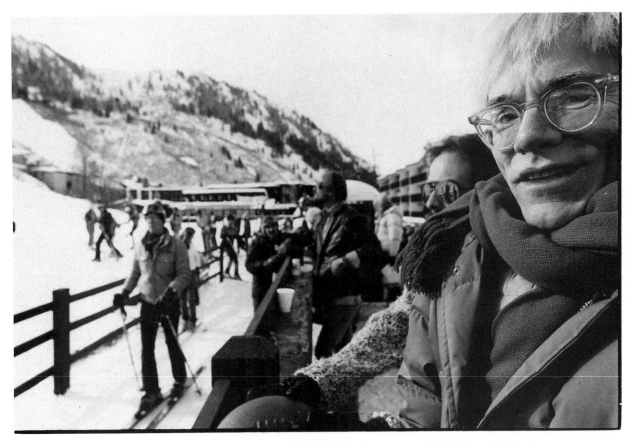

TOP With John Denver and the jet he lent to Andy for the trip to Denver, Colorado. (September 1981)
BOTTOM Having fun waiting for the ski-lift. (5 January 1982)

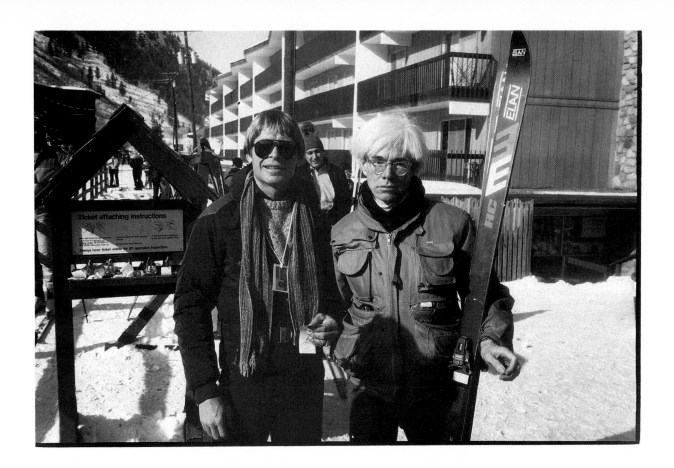

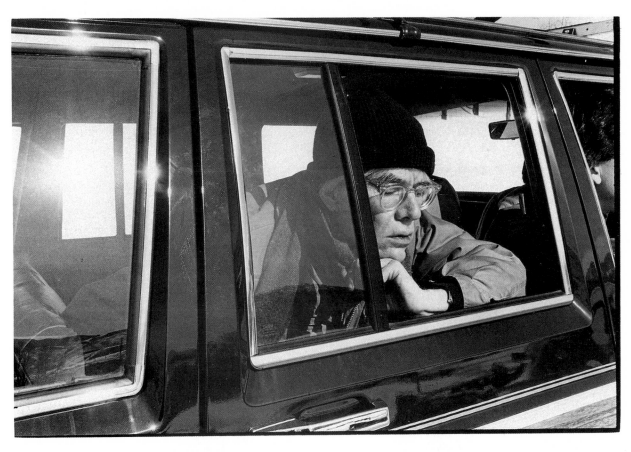

TOP With John Denver at the ski-lift in Aspen. (4 January 1983)
BOTTOM In Andy's rented all-weather, all-terrain jeep. (1984)

NETWORKING

Andy would 'take' an attractive salt-shaker or a piece of china or cutlery from a fancy restaurant just as readily as he would 'take' an idea from someone at lunch and turn it into art. Andy was fond of stealing ideas, and the way he did this was by surrounding himself with interesting and different kinds of people, whose interaction around him would trigger opposing opinions and stimulate clever ideas.

Andy would either twist or misunderstand what was going on and come up with new and original ideas. It was like networking with a group of people that might include royalty, street trash, another painter and the newest kid in town. And he did it every day by going to all the dinners, parties, movies, discos, openings and shops he could.

Andy had more ideas than he could ever have used. His chief problem was that when he expressed any of these ideas he hardly ever got any honest feedback, because most people were too busy trying to impress upon him the fact that they went along with everything he said. But once an idea became established he could really do something with it. That is, with the advice of his business adviser, Fred Hughes, who was in many ways the brain behind the big money Andy made. It was through Fred that Andy obtained portrait commissions and most of his important series commissions.

KIDS

Andy needed to have contact with at least four or five kids a day. He loved smart ones as much as beautiful ones, but if they were dumb, he'd say, 'Oh God, not another one.' He got a lot from young people, and at work he surrounded himself with them. He didn't mind perfect strangers coming up to him in the street, because they gave him fresh energy and made him feel young. He felt more comfortable with children than he did with art collectors and serious fans, just as he did with people like the cafeteria cook he once met at a bus stop, who had never heard of him. He would complain that he didn't like going to

continued on Page 40

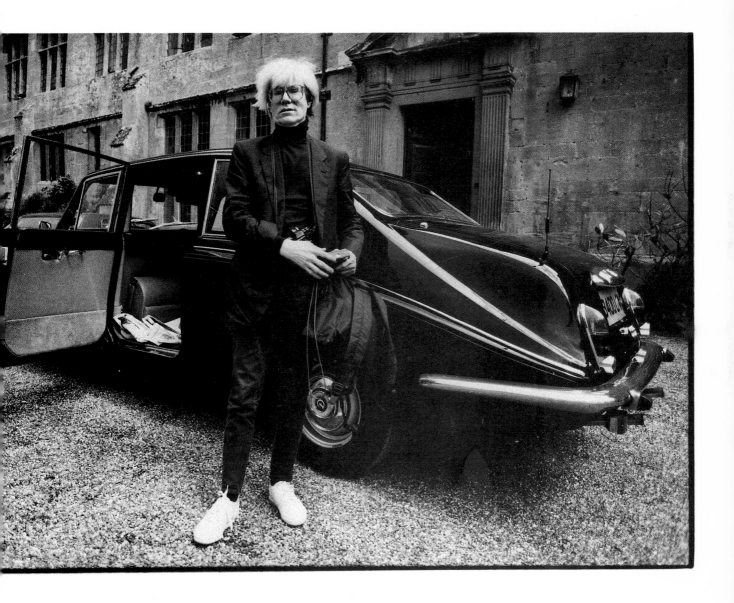

Visiting Lady Neidpath's country house in Gloucestershire. (1986)

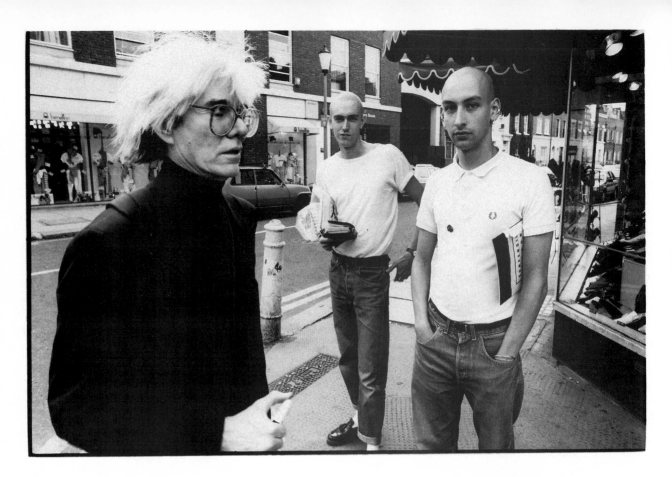

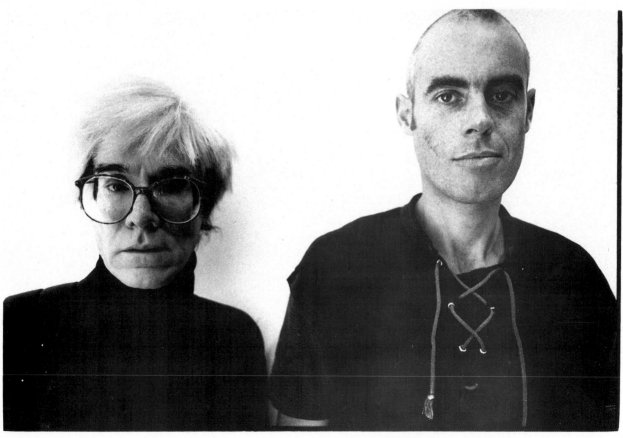

TOP Shopping in London. (1986)
BOTTOM With artist Richard Long at the Anthony d'Offay Gallery, London. (1986)

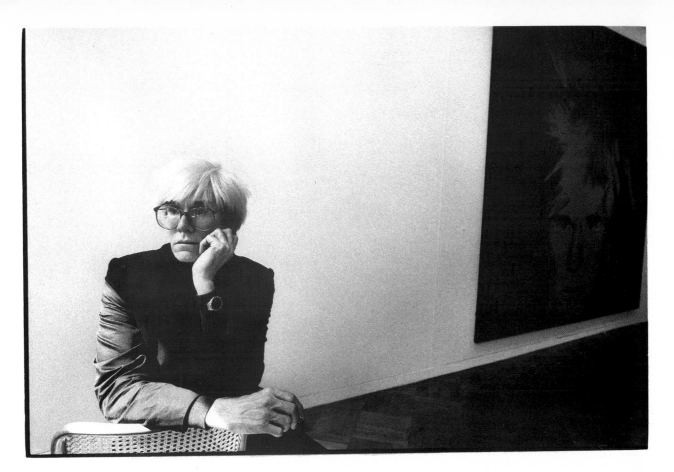

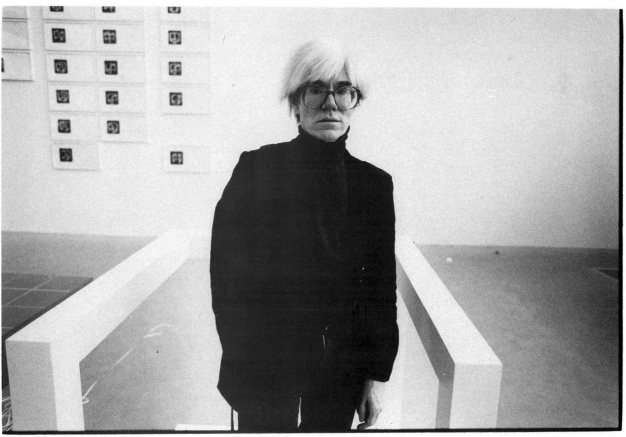

TOP At the Anthony d'Offay Gallery for Andy's Camouflage Self-Portrait show. (1986)
BOTTOM Touring the Saatchi & Saatchi Gallery. (1986)

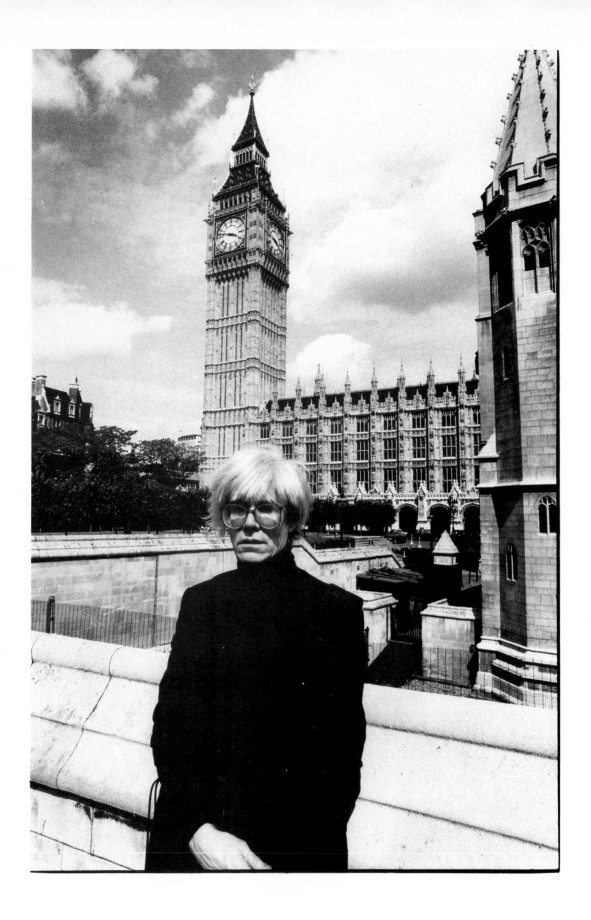

Being a tourist in front of Big Ben. (1986)

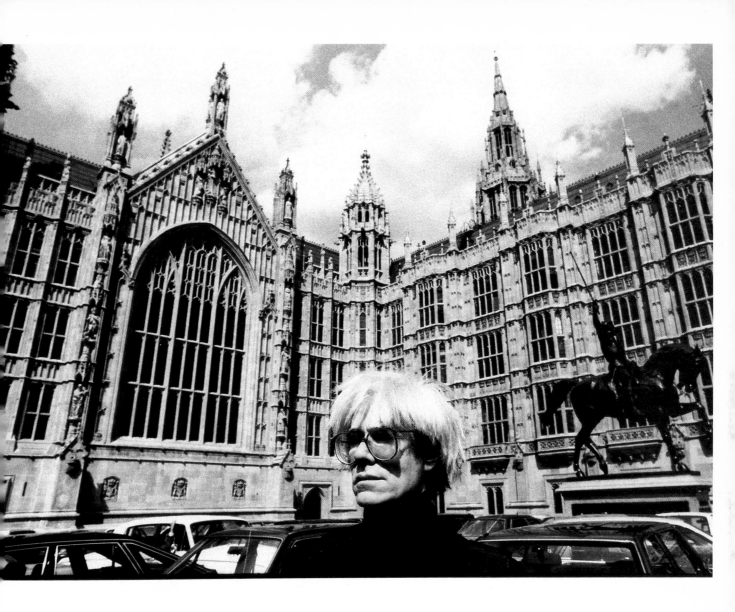

Outside the House of Commons. (1986)

book-signings, but people would show up with all kinds of books and posters and he would just go on signing them until his hand froze up. He would sign a single book in ten separate places and make little drawings in it, if he thought the person asking for his autograph was cute.

MAKING ART

An early image of Andy that I'll never forget dates from one Saturday afternoon, when he called me from the Factory and said, 'C'mon over, keep me company while I paint.' When I got there I saw Andy standing over dozens of yards of white canvas holding a sponge mop and surrounded by large buckets of bright paint. He was painting backgrounds that were to be printed with silk-screened images, probably portraits. And it struck me that here was the legend of the 20th century who just wanted someone around as he was mopping the floor, just like any ordinary American housewife.

He wasn't precious about his work; he did it from nine to five, seven days a week. That was his job. He had great respect for people who did their job, whatever it was; he knew that he could have been a cabinet-maker if things hadn't worked out. As it was, he usually painted from three in the afternoon until seven in the evening, every day including Saturday, and sometimes on Sunday, too, if he was too depressed to go shopping or eat.

HIS LINES

Andy had always liked drawing; that was why he went to art school. It was his line that was special. He was very aware that what he had was a talent. Above all, he liked making art that was profitable. He wasn't removed from his art in the nihilistic way that is often ascribed to him. That impression of Andy came from the interviews when he couldn't find anything to say to the interviewer, and so would say things like 'Let's make this multiple choice,' or 'You tell me what to say.'

In 1986, when we were in Boston promoting his book *America*, he cancelled dozens of interviews

continued on Page 50

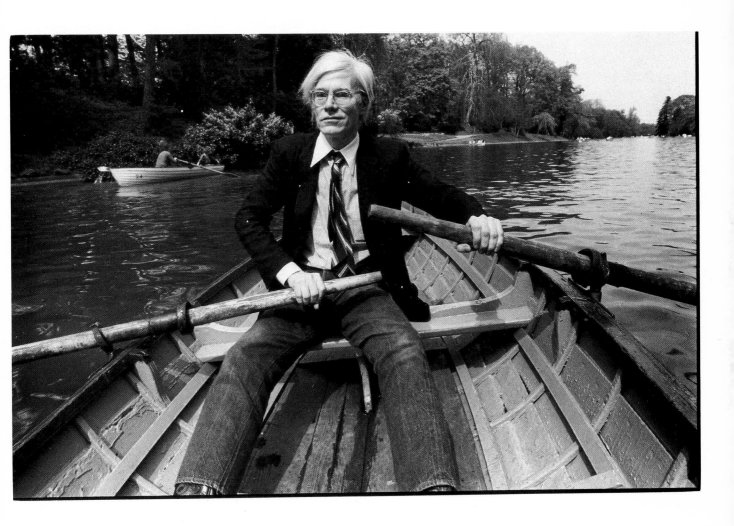

Rowing at the Bois de Boulogne, Paris. (13 April 1981)

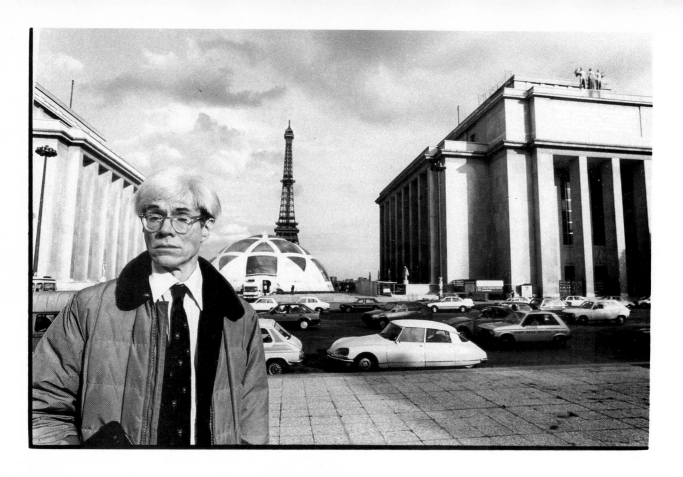

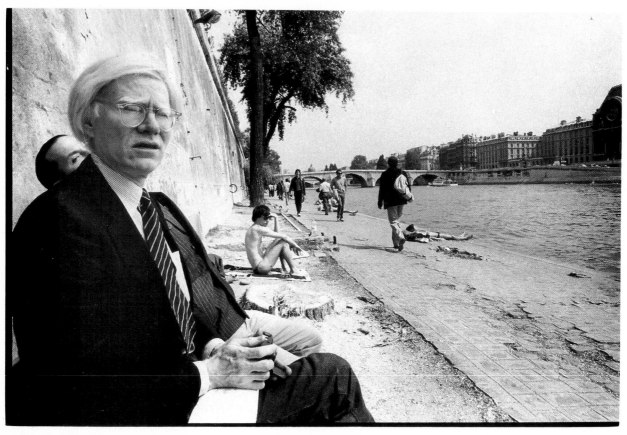

TOP At the Trocadero, Paris. (1 June 1982)
BOTTOM Fred Hughes peering behind Andy while he tans his back on the quay by the Seine, Paris. (19 May 1980)

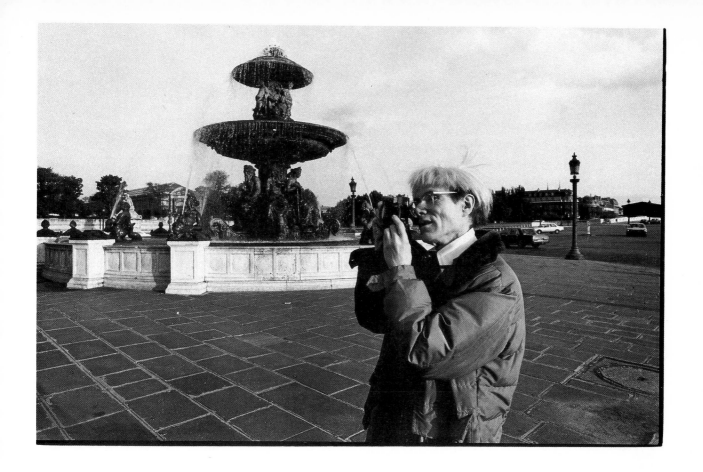

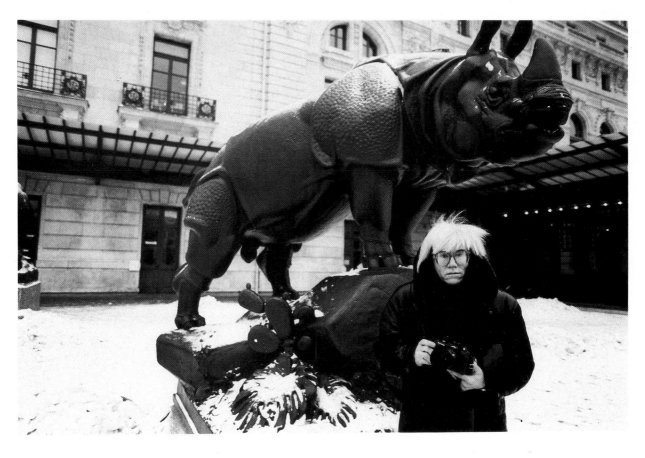

TOP The Place de la Concorde, Paris. (1 June 1982)
BOTTOM In the snow at the Musée d'Orsay. (January 1987)

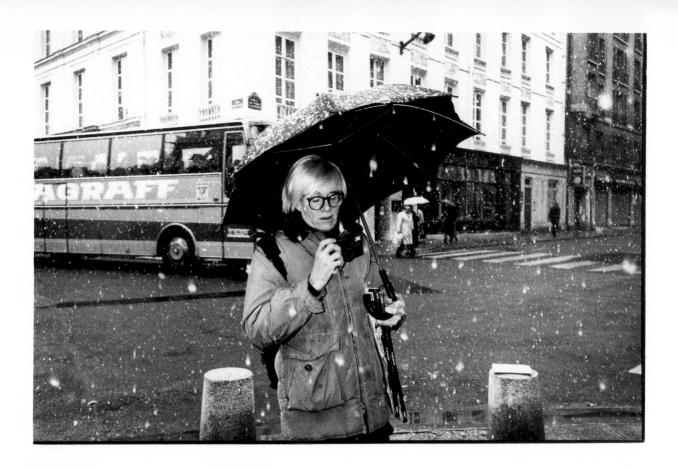

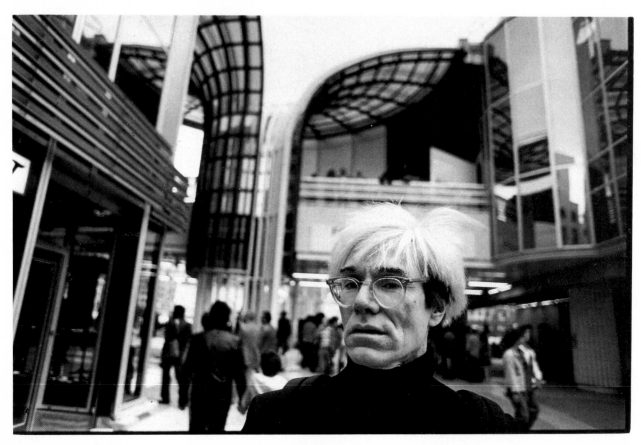

TOP A rare snowstorm in Paris. (1986)
BOTTOM Les Halles, Paris. (1983)

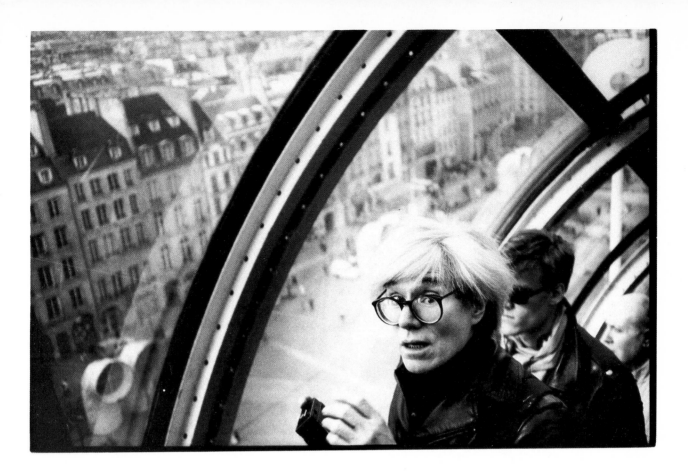

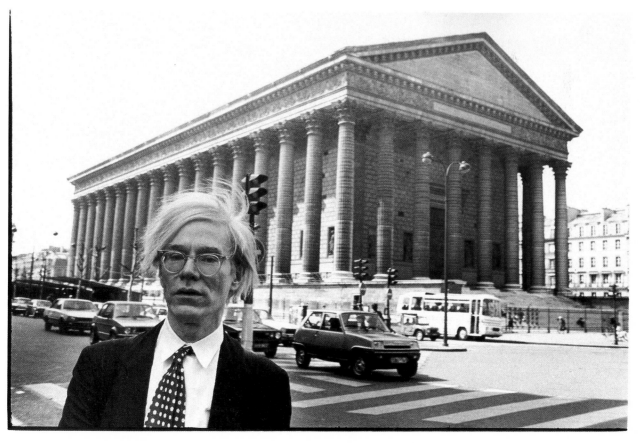

TOP At the Beaubourg in Paris to see the Julian Schnabel show. (1986)
BOTTOM Outside the Madeleine Church in Paris, after shopping at Nino Cerruti. (1981)

Touring Paris. (1986)

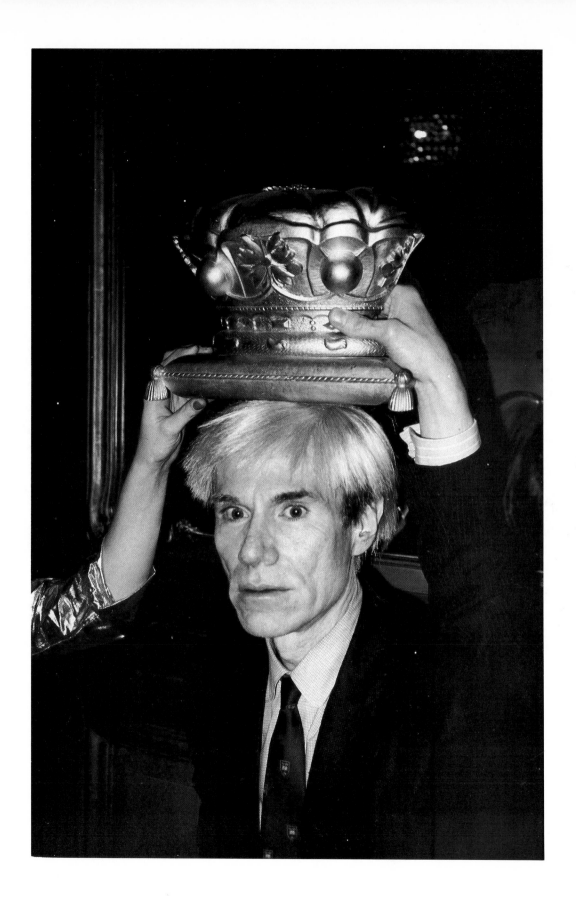

Being crowned at Régine's in Paris. (8 March 1982)

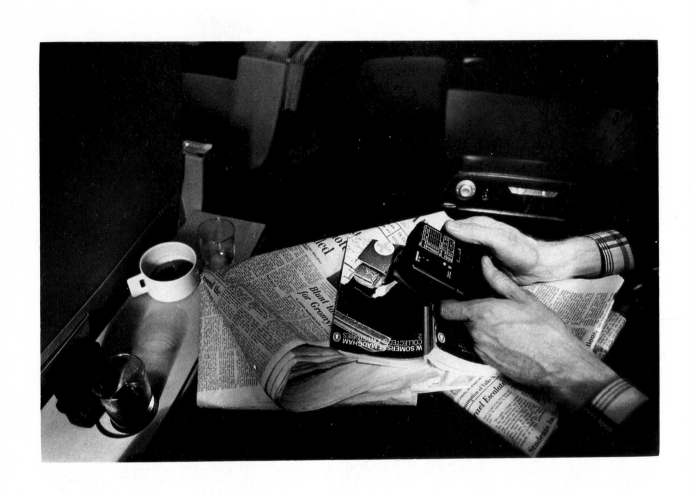

Eating, reading and drinking supersonically on Concorde – Andy's favourite plane ride. (19 May 1980)

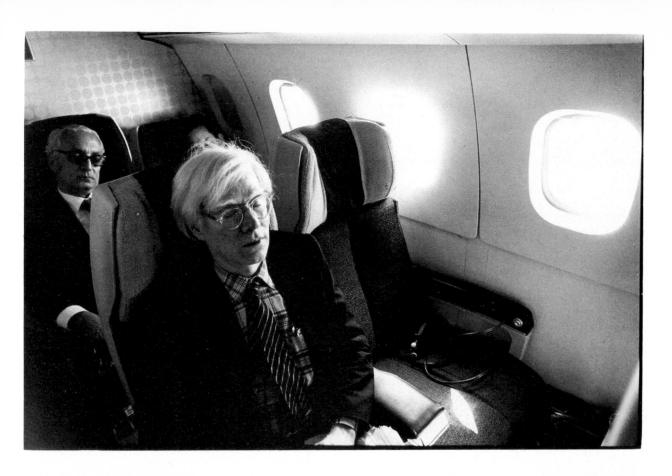

TOP AND BOTTOM From Paris to New York and back on board Air France Concorde. (19 May 1980)

because he wasn't feeling well. One writer somehow turned up anyway, and Andy said, 'Oh, I just don't feel like being interviewed. Let's interview *you*.' That writer got one of the best stories ever, as Andy spent literally hours asking him questions.

THE DEMOCRAT

Andy had a political conscience and contributed in different ways to many campaigns. He painted Jane Fonda's portrait to raise funds for her husband, Tom Hayden's, campaign. He painted Ted Kennedy, and in 1972, when the McGovern people asked him to contribute to their campaign, he painted a nasty portrait of Richard Nixon that was just the job. He especially loved the Kennedys because they were so glamorous and liberal – just like him.

He was a great democratic influence. Once we were walking down the street when a black limousine pulled up and a dark window rolled down and there was Diana Ross, screaming out, 'Andy, Andy, come say hello.' Andy didn't hide in a stretch limo; he was out there for everyone, whether it was Diana Ross or a tourist from Ohio. Andy travelled by taxi; he was the star in the streets. I never once saw him refuse an autograph or a photograph to a stranger. He got tired of it, but he felt he had a responsibility to everyone who recognized him. He'd sometimes say, 'It's so great to get home and take off my Andy suit.' But when he was in his Andy suit, he was on show, and he played his part.

LITTERBUG

Andy used to drop litter, something that seemed quite incongruous with everything else he believed in. Once, when we were walking down the street in Soho, he got tired of an ice-cream cone so he just tossed it. It was very embarrassing because there was no mistake: Andy was a litterbug. Maybe he did it to give people jobs . . .?

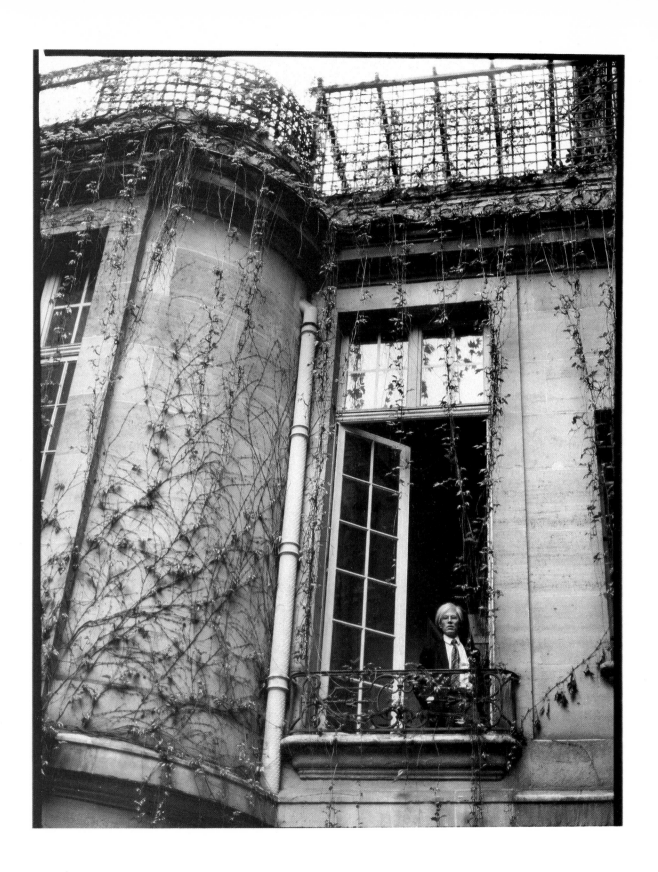

Farewell to Paris. (13 April 1981)

NEW ART

Andy was always thinking of ways he could make new art. All well-known artists who become famous for a specific style – which in Andy's case was Popism – have continually to produce more and more of that kind of art to sell. He had a responsibility to collectors and art dealers.

SCULPTURE

Andy was tormented by being unable to come up with new sculpture that was as original and important as his Brillo boxes of the early 1960s. He had many ideas but none of them really gelled. His unsuccessful sculpture attempts included filling boxes of Schraft's chocolates with cement, then rewrapping the boxes with the original cellophane and ribbon; printing images from *The Daily News* on tin, then crumbling them; and pouring cement into large, square-based cardboard boxes as moulds, then signing the wet cement with a stick. These cubes of concrete became his biggest albatross, because they couldn't be budged without three guy-ropes and a dolly. They were ugly and nobody liked them. They weren't really Andy anyway.

In the months before he died, Andy was working on a design for a Piaget watch. He loved Salvador Dali's 'dripping watch'. Andy talked about designing a 24-hour watch.

ART WORLD

Andy was a great supporter of other artists' work. He was very fond of Jean-Michel Basquiat, Keith Haring and all the younger artists. The only thing he didn't like was to see someone doing something that he'd already seen done to death. He didn't mind imitators but it was no good their churning out stuff that looked just like other people's; they had to be clever and make their work look fresh. He himself loved the Goyas and the Renaissance paintings in the Prado as much as he loved anything current.

GOING OUT SELLING ART

Andy went to discos because there were advertisers and people who might commission portraits there; that was where business was conducted. It was a game: he'd speak to an advertiser or potential client in a dark club and they'd sign a contract the next day. In the seventies, the power people were at Studio 54; the brat pack in those days consisted of Halston, Calvin, Andy, Mick and Bianca Jagger, Truman and Steve Rubell. In the eighties, the place to be was the Michael Todd Room at the Palladium, although there weren't nearly as many 'glamorous business people' on the scene. But Andy wasn't about to give it all up just because clubs had become a bore in the eighties. Now that he's gone I think a lot of people miss him; he'd become such a fixture that his absence is like vanished furniture all around town. He inspired a lot of late-night people just by showing up at these places. But Andy's night-life notoriety harmed his reputation as much as it paid off financially. When the *People* magazine image of 'say-nothing' Andy finally fades, the true nature of his contribution as a conceptual and pop artist will be re-established.

RELIGION

Andy went to church every Sunday. A lot of his friends were Catholic. He may have related better to us Catholics because we all have the same background: mass, priests, nuns, Catholic school, a sense of guilt. His religion was a very private part of his life. In church he was Andrew Warhola and not the cool pop star Andy Warhol. I think it took a lot of pressure off him. It restored to him a perspective of the world that he had grown up with. In church he was the anonymous Catholic.

HEALTH

Andy had a masseur who got him interested in eating raw garlic, which, besides being a health fad, also reminded him of his Czechoslovakian ancestors, who used garlic as a cure for everything. The smell got

pretty unbearable at times, and if it hadn't been for the heavy perfumes he wore, even Andy couldn't have got away with it. Then he got hooked on crystals and he wore them, carried them and put them in the pot when he boiled water for his herbal teas. He was searching for spirituality.

EATING OUT

When Andy first came to New York, he used to go to Serendipity, which is a restaurant near Bloomingdales, a world full of princesses just hanging about. They serve food like foot-long hot dogs, enormous portions of shepherd's pie and frozen hot chocolate.

Andy was a secret binger, and sometimes I'd get a late-night call from him confessing that he'd just eaten a whole box of Kron or Godiva chocolates that an art dealer such as Bruno Bischofberger or Thomas Ammann had brought back from Switzerland that day on Concorde.

At the old Factory, 860 Broadway, Andy used to have mad rushes to buy lunch from the McDonald's across the street. What he really liked about going to McDonald's was the process of buying the multiple quantities of food containers, rather than the contents. Naturally, from this kind of food we graduated to dinners at the better restaurants, such as the River Café, il Cantinori, La Grenouille and Le Cirque.

A FANCY SOUP KITCHEN

One Saturday night a group of six of us were having drinks at the Mayfair Hotel bar and we couldn't decide where to eat dinner. Someone suggested Le Cirque, but it was nine o'clock and we were sure we'd never get in. Still, we decided to try — and we could hardly believe that they were able to make room for us, because the place was packed. We had a lovely meal, and when Andy asked for the bill, he was informed that dinner was on the house. Andy was really touched, because Le Cirque was a New York institution that wasn't short of business. He told Sirio,

continued on Page 74

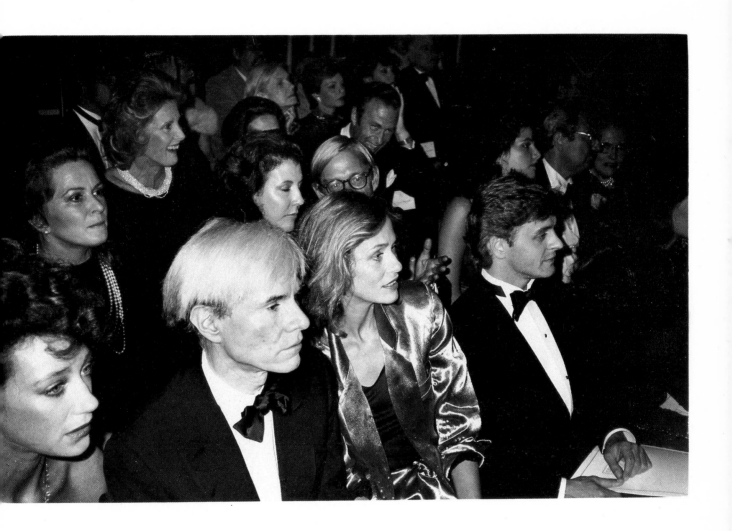

Left to right: Marisa Berenson, Andy, Lauren Hutton, Mikhail Baryshnikov; at a fashion show in New York City.
(4 October 1982)

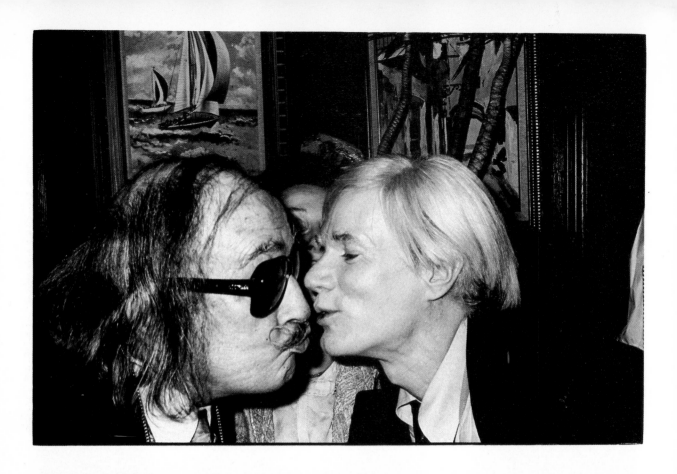

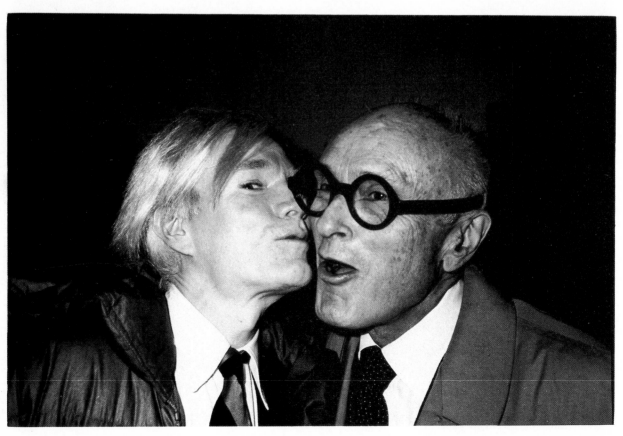

TOP Kissing Salvador Dali. (21 March 1978)
BOTTOM Kissing architect Philip Johnson. (6 March 1979)

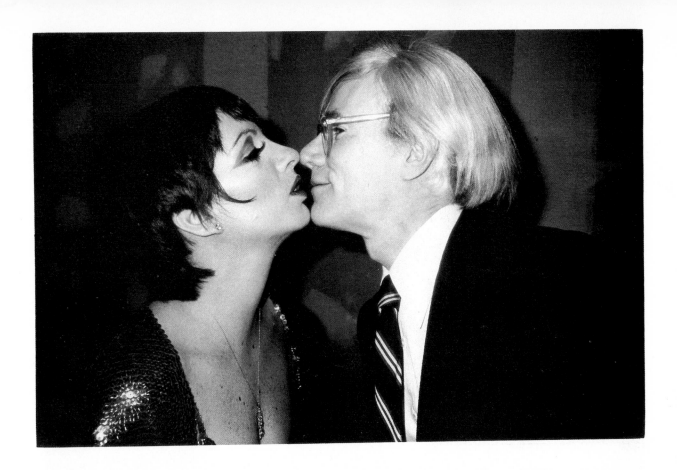

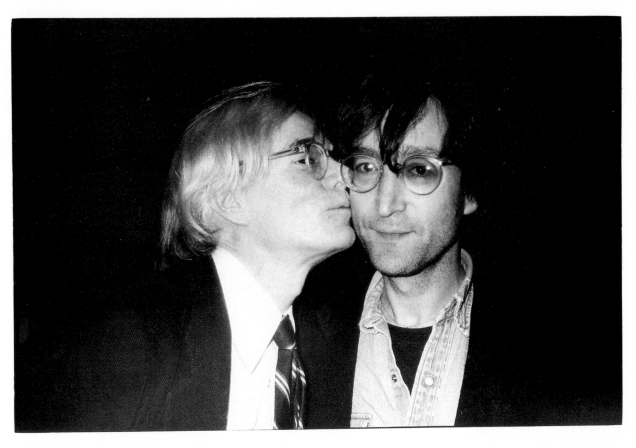

TOP Kissing Liza Minnelli at the Factory, 860 Broadway. (21 February 1978)
BOTTOM Kissing John Lennon at the Factory. (21 February 1978)

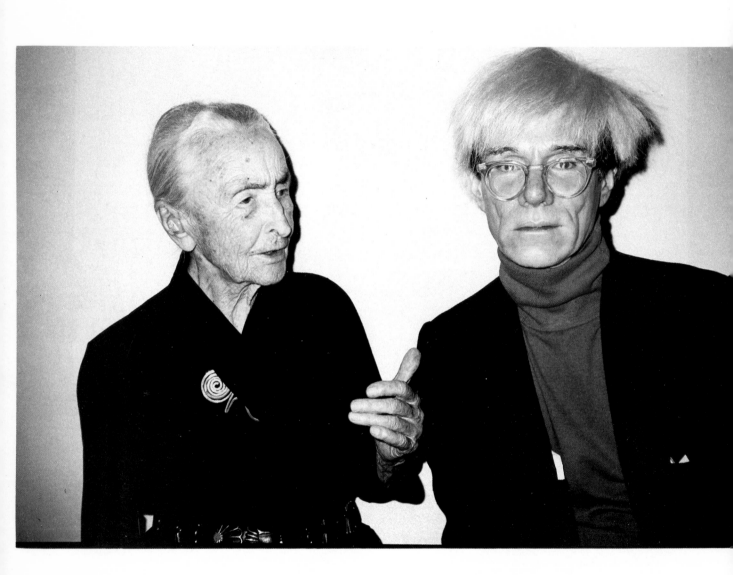

Fooling around with Georgia O'Keefe during a break while doing her portrait at 860 Broadway. (17 June 1983)

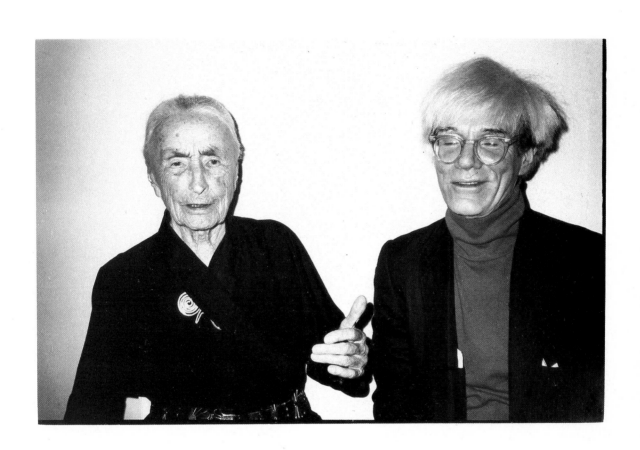

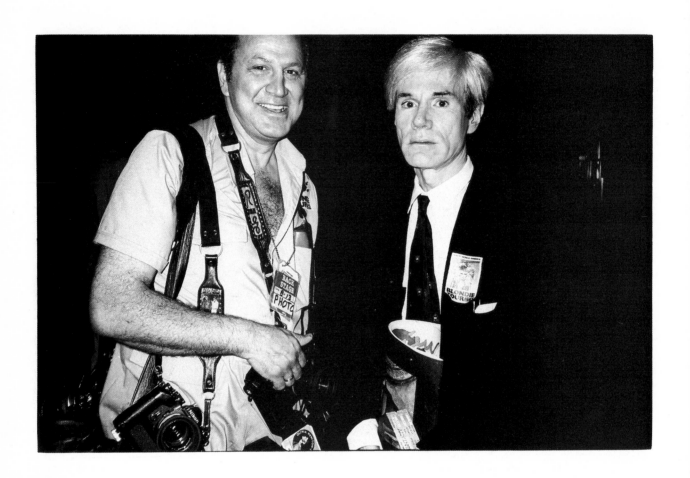

Andy's favourite paparazzo, world-famous Ron Gallela. (16 August 1982)

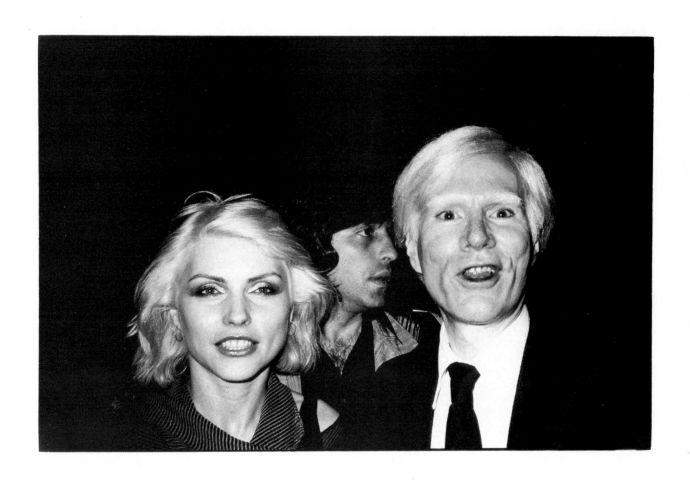

Andy's favourite pop star, Debbie Harry. (20 June 1979)

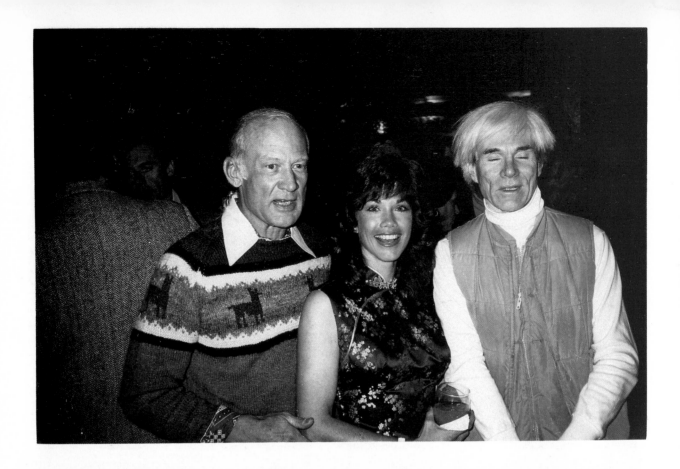

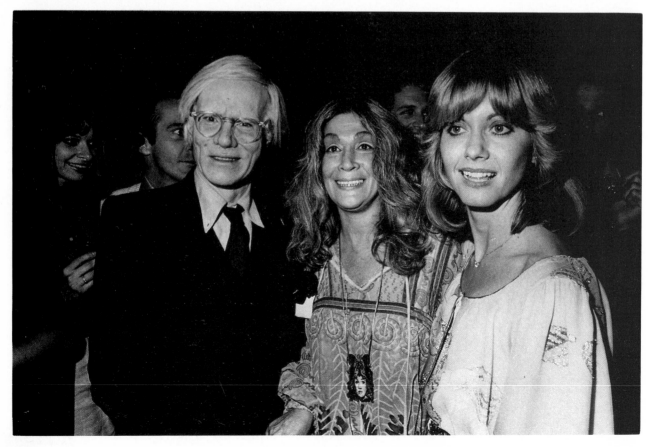

TOP A New Year's Eve party with Buzz Aldrin and Playboy playmate Barbie Benton. (1983/84)
BOTTOM At a party for Dolly Parton at the World Trade Center with Sylvia Miles and
Olivia Newton-John. (9 May 1977)

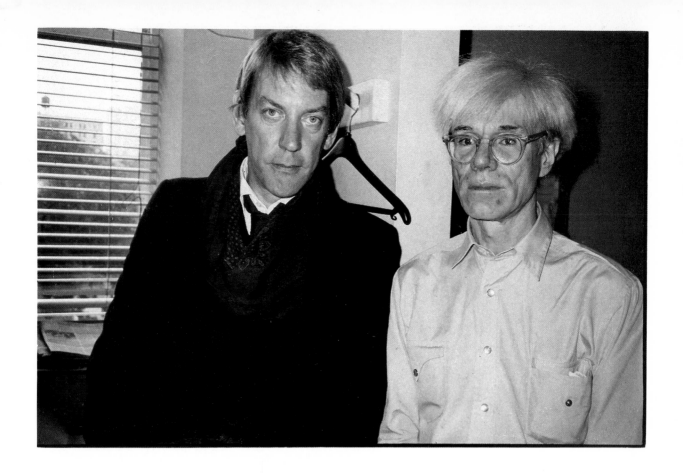

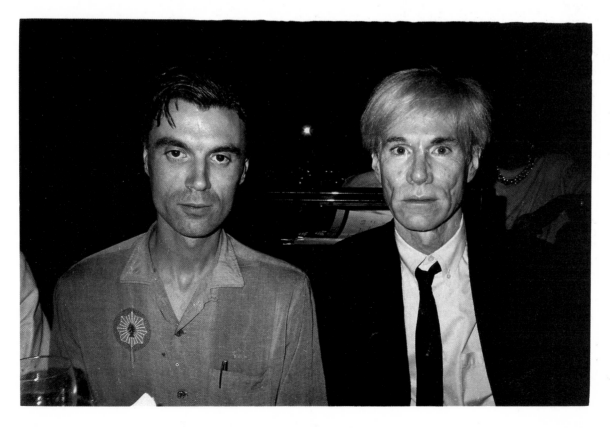

TOP With Donald Sutherland at 860 Broadway. (4 October 1982)
BOTTOM With David (Talking Heads) Byrne. (23 June 1982)

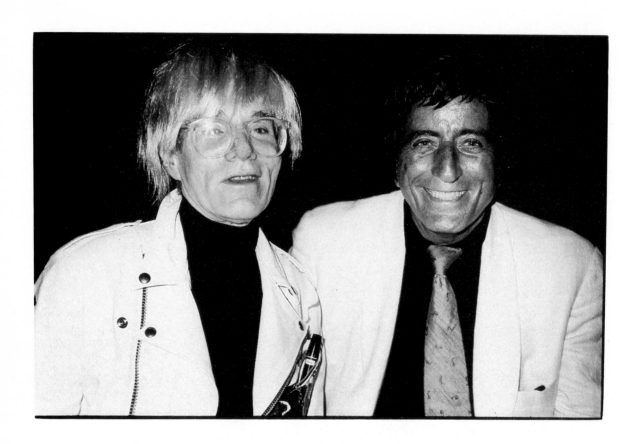

With Tony Bennett at the opening of Peter Gatiens' Limelight in Chicago. (12 August 1985)

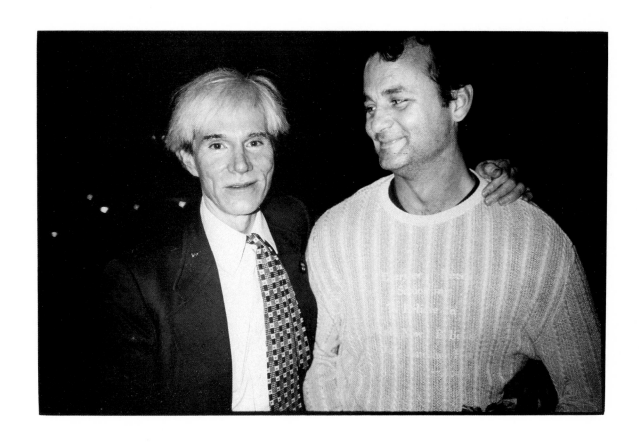

On the street in New York City with comedian Bill Murray. (4 June 1981)

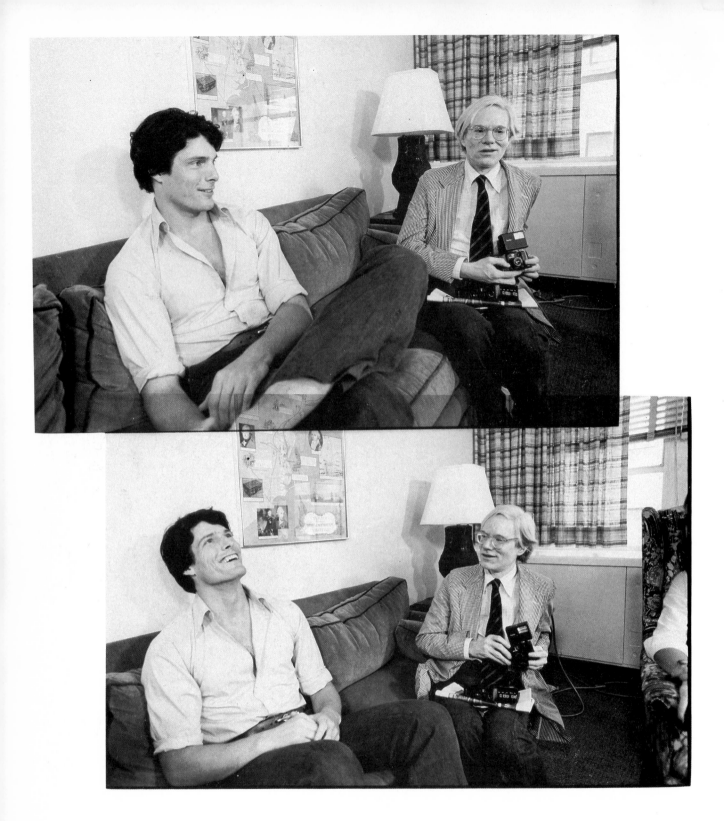

Inside the New York *Daily News* building with Superman, Christopher Reeve. (19 July 1977)

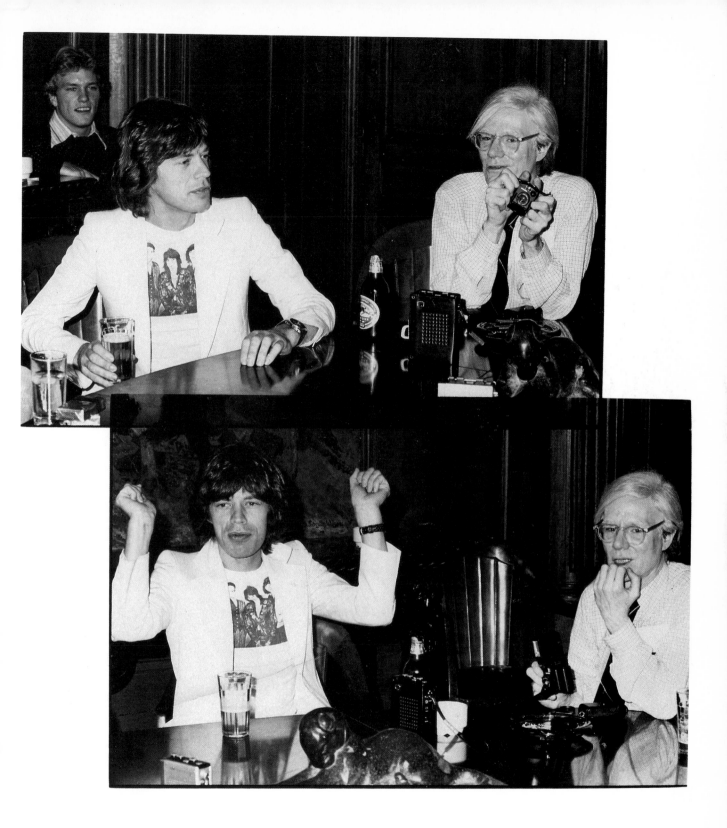

Lunching with Mick Jagger at the Factory, 860 Broadway. (3 October 1977)

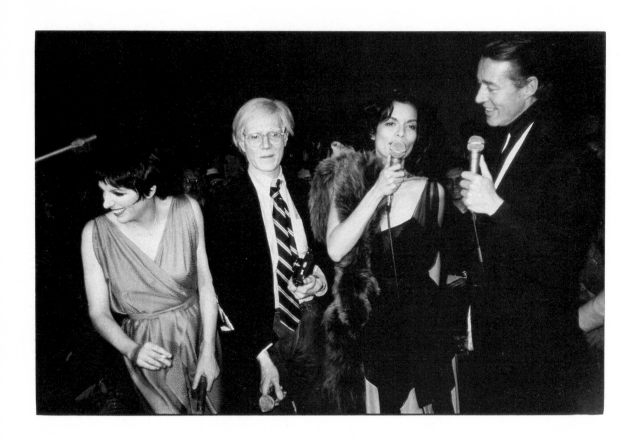

The Gang of Four at Studio 54: Liza,
Andy, Bianca and Halston. (27 April 1978)

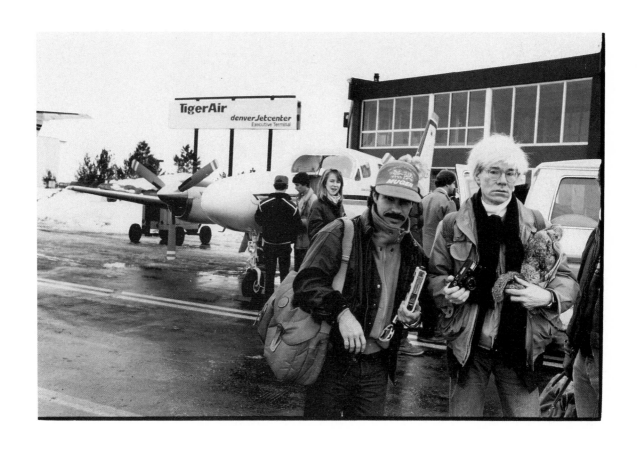

Rock star John Oates at the private air terminal to make a connection from Denver to Aspen; John's wife, Nancy, in the background. (4 January 1983)

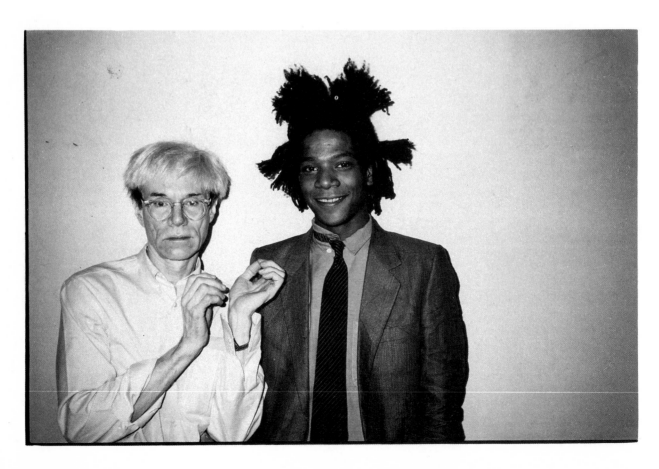

70 TOP With artist Kenny Scharf at a Hallowe'en party at Nell's club in New York City. (October 1986)
BOTTOM Jean-Michel Basquiat at 860 Broadway. (12 October 1982)

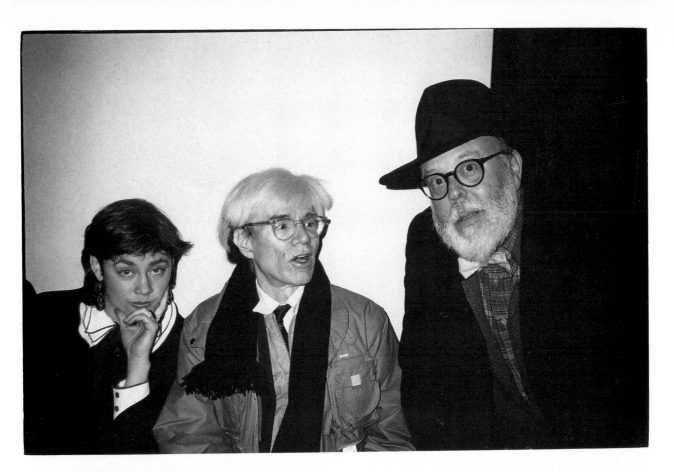

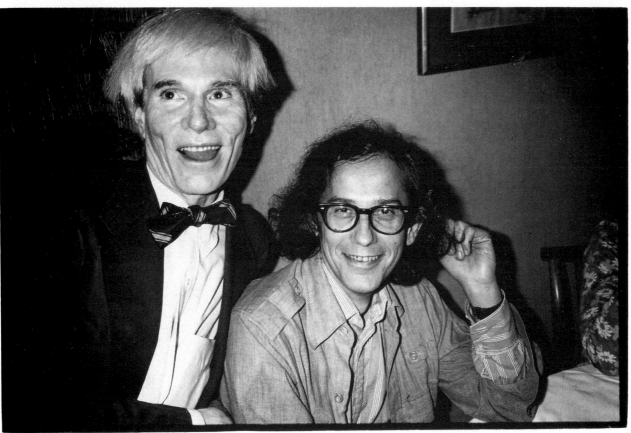

TOP US Senator Patrick Moynihan's daughter, Maura, with art guru Henry Geldzahler. (4 January 1983)
BOTTOM At dinner with artist Christo. (4 June 1981)

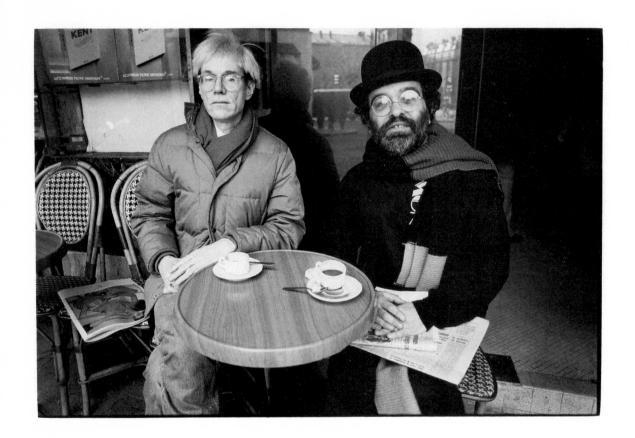

Andy with writer Fernando Arrabal at the Café de Flore in Paris. (8 March 1982)

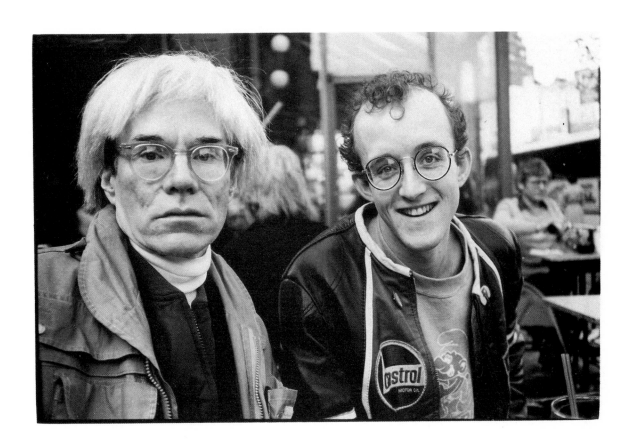

Pop artist Keith Haring in New York City. (20 April 1983)

the maître d', 'It's so nice to have such a high-class soup kitchen just a few blocks away from where I live.'

DINNER WITH DALI

A few years before that occasion, Andy gave a dinner for Salvador Dali and his wife, Gala, during their annual pilgrimage to New York. The dinner was held at the St Regis Hotel, where Dali had stayed every spring for the past 20 years. At one point in the evening, the two exchanged gifts. Andy pulled out one of his recent paintings of crosses, and Dali seemed pleased. Then Dali reached round and pulled up to the table a large clear plastic bag full of rubbish. Andy said, 'Oh, that's great. What is it?' Dali said, 'This is trash from my studio.' Andy just nodded vaguely and smiled, because he thought that his own gift to Dali was so much more valuable, while all he got was a bag of rubbish. It was original, but it didn't seem to be worth very much. He would rather have had a painting or a piece of jewellery — something, at least, that required insurance.

A GOOD LIFE

I always got the feeling that Andy was trying to show me the good life, as if to say, 'If you really work at your art you can make twice as much money as me and lead a good life.' Sometimes he'd talk about how small my apartment was or how I could better my life. But Andy had grown up in the thirties and forties and had been very much deprived of the 'good life'. I'd grown up in California in the sixties, when there was nothing *but* the good life. That 'good life' was his ideal, not mine. His seven-days-a-week work ethic was part of his working-class Eastern European background, and it was contagious — everyone around him adapted to it — Andy used to paint even on Christmas Eve.

TRAVELLING

Before we left to go on any trip Andy would always be a total mess. He'd have me call him at the crack of dawn to arrange the time I was to pick him up

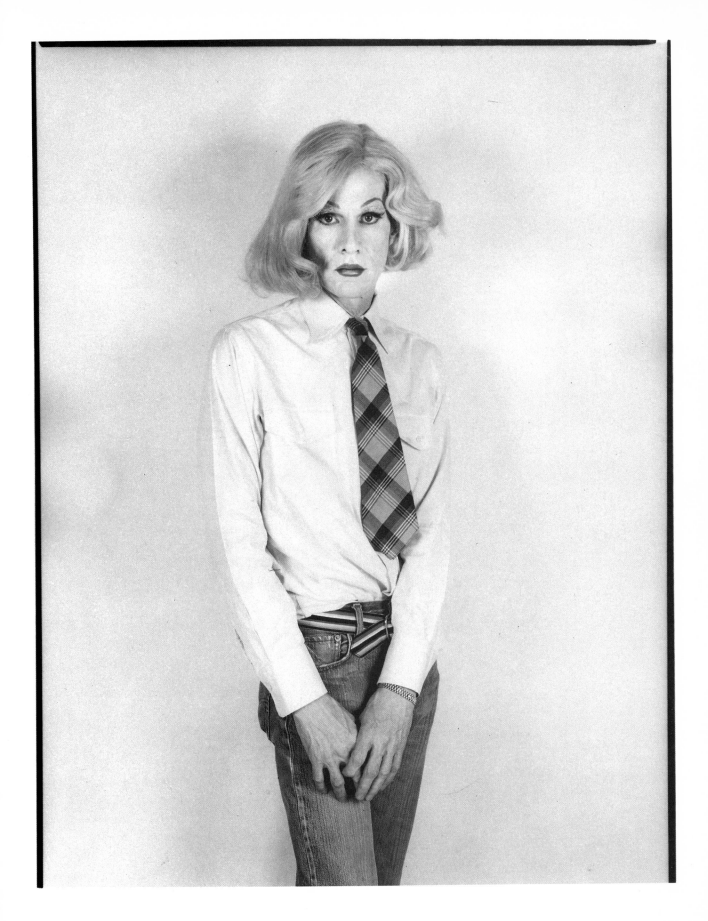

'Altered Image', inspired by the Man Ray photo of Marcel Duchamp in drag called 'Rose, c'est la vie'. (10 May 1981)

at his house on East 66th Street, and when I got there he'd always make me wait while he ran back upstairs to change all his clothes or spray on perfume, or panicked because he couldn't find a 30lb box of *Interview* magazines that he wanted to drag along. He'd always find some excuse to dither around for another 10 minutes, so that when he finally did get down to the car the traffic was really something to worry about.

Towards the end, Andy used to pack only black clothes. He thought wearing black was great because it was easy; he loved the idea of simplification. But not all black matches, so there was a lot more to 'packing black' in a hurry than you'd imagine. Also, since everything black tends to look the same, he'd end up packing clothes that were dirty or torn. Andy often wore clothes with rips in them, but he had so much style that he could make them work.

Andy didn't like travelling, he liked being there. He was wild about Concorde, because of the speed, and he was equally wild about the VIP lounge, which is probably one of the most exclusive conference rooms in the world. You could meet anyone there, from Roger Moore to the president of Perrier. All you had to do to make friends was drop your bags in the seat opposite them — and they were yours. The next day you'd see them at Café Deux Magots, and it was like meeting old friends. In all the dozen times I flew on Concorde with Andy, there wasn't a single one when he didn't make a collection of the cutlery and china. 'It's designed by Raymond Loewy and it's going to be really valuable in the future,' he'd say. 'We've got to get a set of it. Ask the lady in the aisle seat if you can have her fruit cocktail.' Andy had more than enough of this tableware for a dinner party.

The first thing Andy would do at a hotel was order room service. Andy really was a princess. He'd order tea, and sandwiches that he could pick apart, and then at night he'd have cognac and a box of chocolates sent up. And he'd get pretty irritable if he

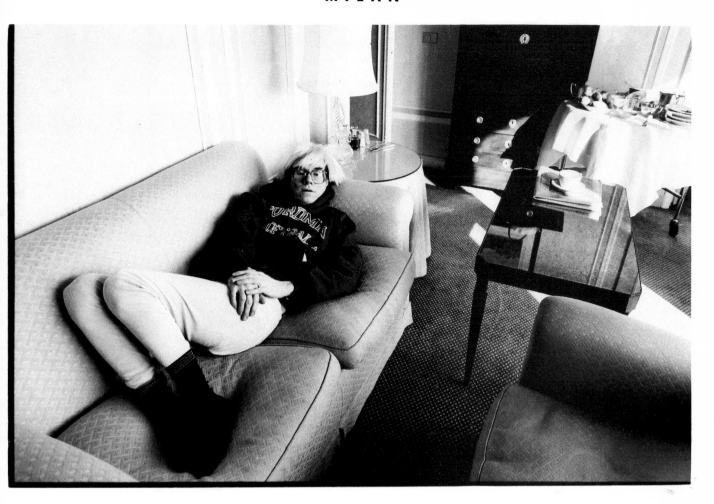

Lounging at the Hotel Principe di Savoia in Milan. Andy's gallstones were starting to bother him, and this was the beginning of the illness that eventually put him in New York Hospital, where he died. (January 1987)

couldn't get his chocolate. But during the last trips, he'd order only camomile and rose-hip teas until you were ready to drop.

PARIS

When we were in Paris, the American male models were wrapping their heads in bandanas and scarves. We thought this was ugly, but in Paris the rules of the game are to follow the fashion, so Andy and I started showing up at fancy parties with scarves tightly wrapped round our heads. We even wore them at a party given for Halston at Régine's.

When we got back to New York we continued with the Paris look, until finally it just became too embarrassing. The last time we wore the scarves was on a helicopter trip we took from the World Trade Center round Manhattan. Nobody said anything, because it was Andy Warhol, but we got too many stares, even for us. What looks good on Bruce Weber and his models didn't look so hot on Andy and me on Madison Avenue.

FRENCH PERFUME

Andy was wild about perfumes. At first I didn't really understand his enthusiasm for going into these girlie shops; they were just so stinky. But I did like it, because these great perfumeries in Paris looked like spreads out of a 1940s *Vogue* magazine. The women customers were meticulously dressed and the clerks wore sharp-looking uniforms. Somehow we used to end up in these places two or three times during every trip. Andy really liked this environment, maybe because when he was growing up he'd never been in a fancy shop at all, and the ultimate fancy shop is a woman's perfumerie in Paris. It's so superficial and excessive, and Andy's interest was as much in the beautiful crystal perfume bottles and the way they wrapped the boxes as it was in the scent itself. His favourite perfumes were Chanel No. 5, all the Guerlain scents (because they came in Lalique crystal) and mixtures of essences that he'd either have concocted professionally or mix himself.

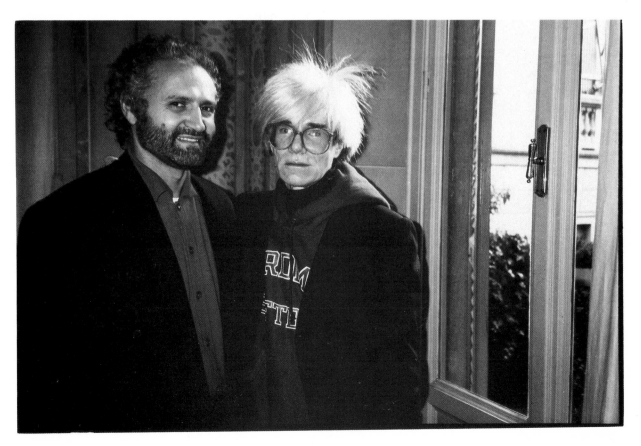

TOP At the gallery in Milan where Andy had his last exhibition, which was his interpretation of the Last Supper. (1987)
BOTTOM Posing with Italian designer Gianni Versace at a luncheon for Andy given by Gianni at his home in Milan. (January 1987)

SHOPPING

I always felt like the poor stepsister. When we went shopping in Paris, Andy would encourage me to buy clothes whenever he did. He'd casually pick up $400 shirts and $900 jackets, while I'd stand there fidgeting with my credit card, trying to translate francs into dollars to the nearest cent.

DINNER IN PARIS

The dinners in Paris, like the dinners everywhere, would go on and on, and Andy would just sit there and let someone yap in his ear till he just about collapsed. That is not to say these conversations were one-sided. Andy led the public to believe that he had little to say, but anyone who ever sat next to him at a really high-powered dinner would laugh at that. He was a great listener — as are most great people — and he was shy about talking about himself, but he had many opinions and could ask more questions than Orianni Fallaci.

There would always be one of us in his travelling party who was responsible for getting him away from these dinner parties when we had to sneak off to another party or a disco, and ungluing him from someone's ear was an art in itself. For example, one of us might announce 'Mr Warhol, we've got an appointment with the countess, and she asked us not to be late.' Really, sometimes I felt like a male nurse.

MILAN

For the opening of Andy's 'Last Supper' paintings in Milan, we all had a terrific time because the paintings looked wonderful, and the city was full of wild fashions and great-looking models there for the shows. The performance art director, Robert Wilson, was also in town premièring his 'Salome' at La Scala. But Andy was just starting to get sick with his gall bladder disorder. He began ordering chicken soup everywhere we went. He was very secretive about his not feeling well; he didn't want anyone to know. Towards the end, the kind of food that Andy really

continued on Page 98

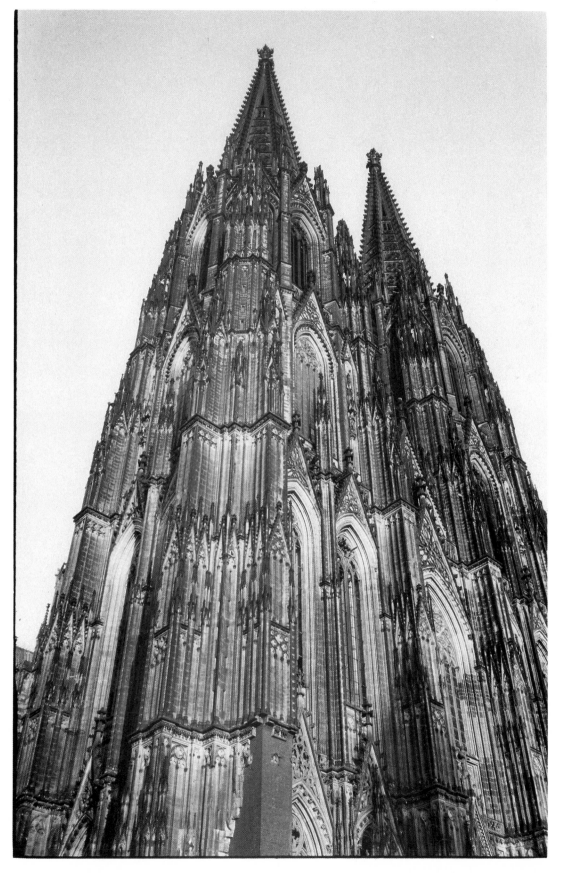

Cologne Cathedral. Andy later bought this photo and used it in his German Monument series. (1980)

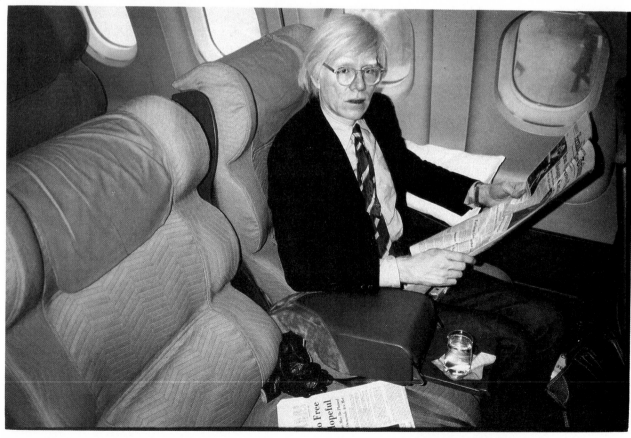

TOP In Düsseldorf, at a circus that art dealer Hans Meyer took Andy to see. (11 July 1980)
BOTTOM On board Lufthansa – first class – at Düsseldorf airport. (7 November 1980)

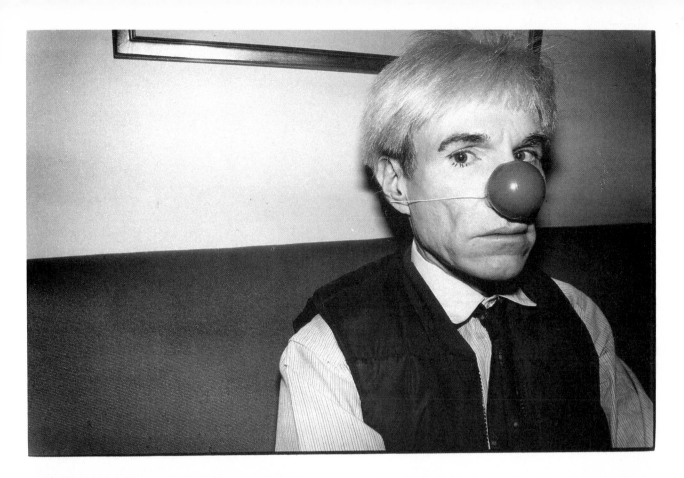

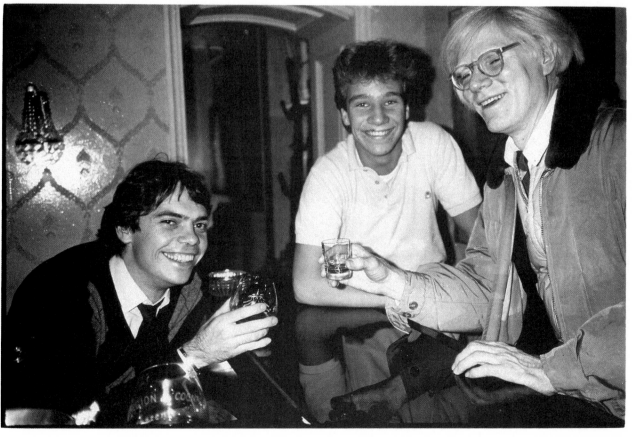

TOP Goofing off during Lent at the Hotel Bauer Lac in Zürich, Switzerland. (8 March 1982)
BOTTOM Drinking Courvoisier with friends in Stuttgart, West Germany. (7 November 1980)

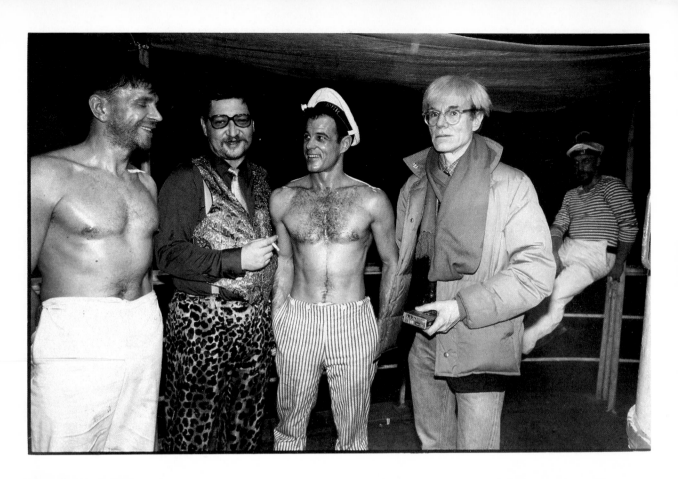

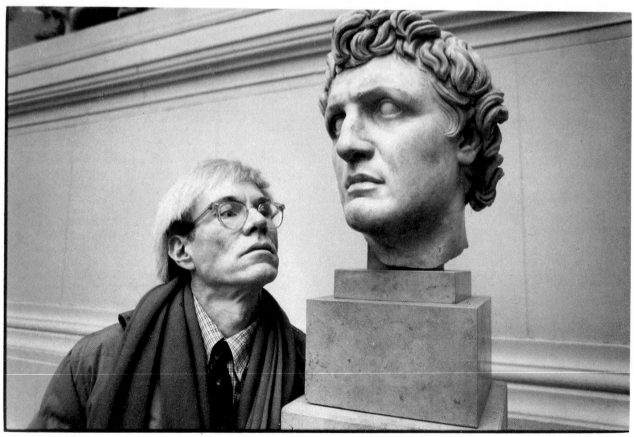

TOP In West Berlin on the movie set of *Querelle*, with director Fassbinder, in the spotted trousers, and actor
Brad Davis, in the striped trousers. (March 1982)
BOTTOM Mugging with a Roman bust at the Pergamont Museum in East Berlin. (March 1982)

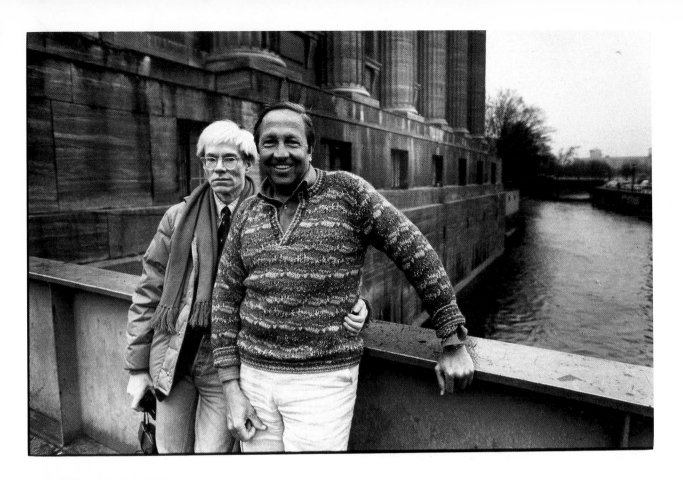

TOP With artist Robert Rauschenberg outside the Pergamont Museum in East Berlin. (March 1982)
BOTTOM The tail-end of an exhibition signing in Germany. (August 1981)

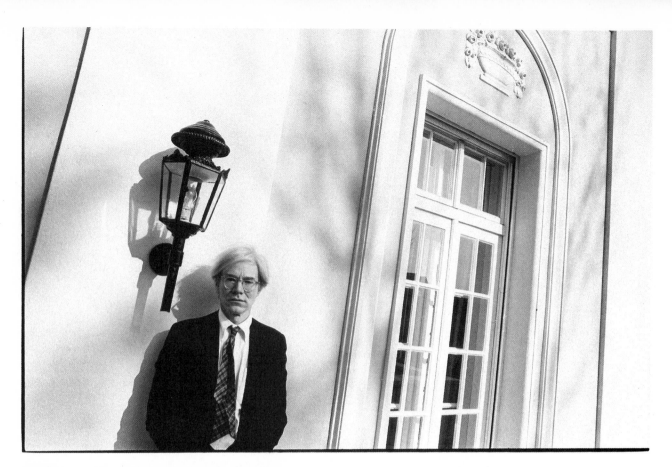

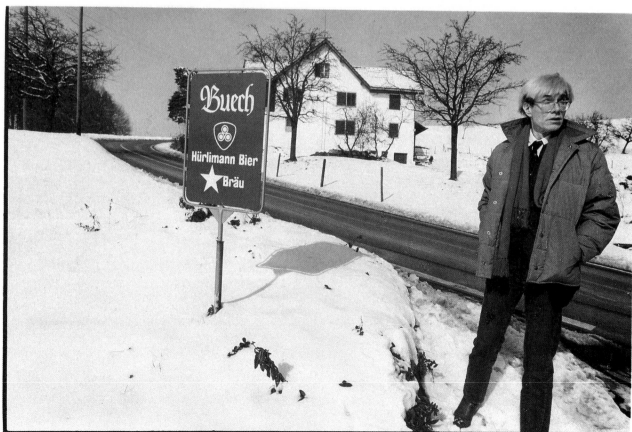

TOP Posing outside the home of the subject of a portrait commission in Vienna, Austria. (13 April 1981)
BOTTOM Somewhere outside Bonn, West Germany, waiting to have lunch at the local Bratwurst Haus. (8 March 1982)

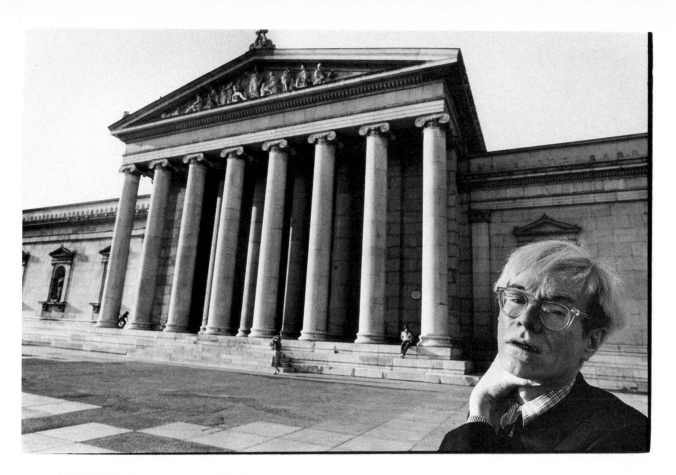

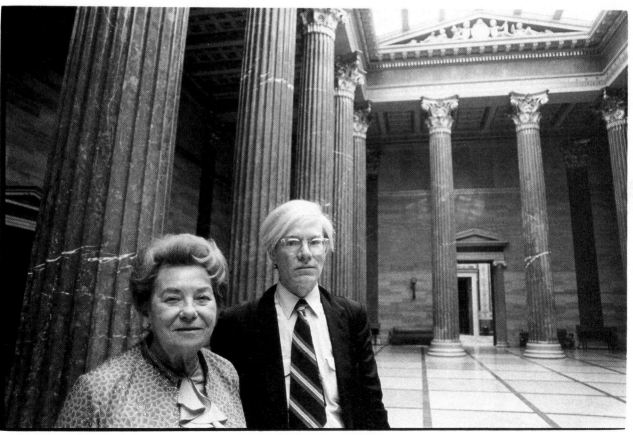

TOP In Munich, West Germany. (13 April 1981)
BOTTOM In Vienna. (13 April 1981)

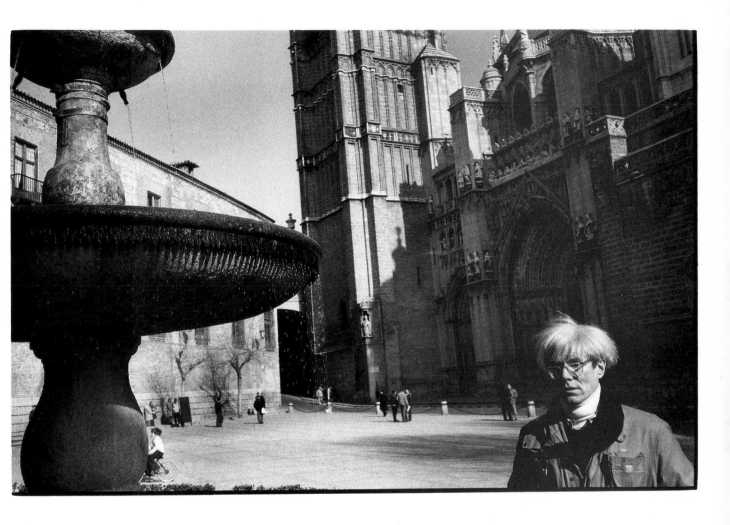

In front of the Cattedrale de Toledo, Toledo, Spain. (January 1983)

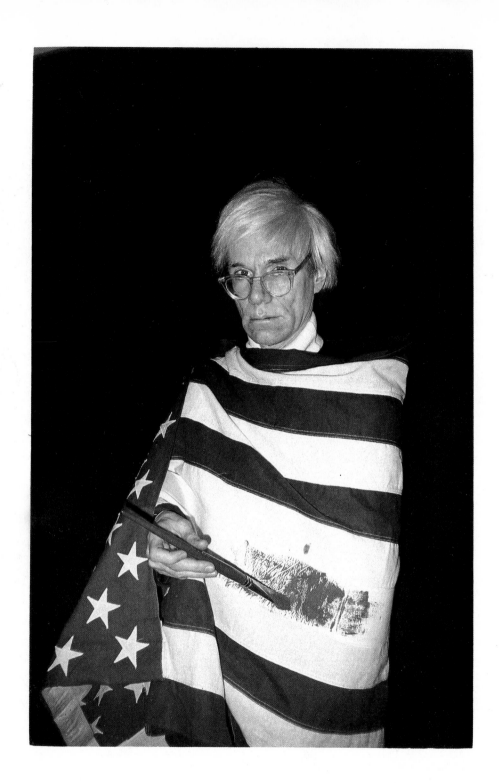

Posing for Spanish photographer Alberto Schommer at the Galleria Fernando Vijande. (January 1983)

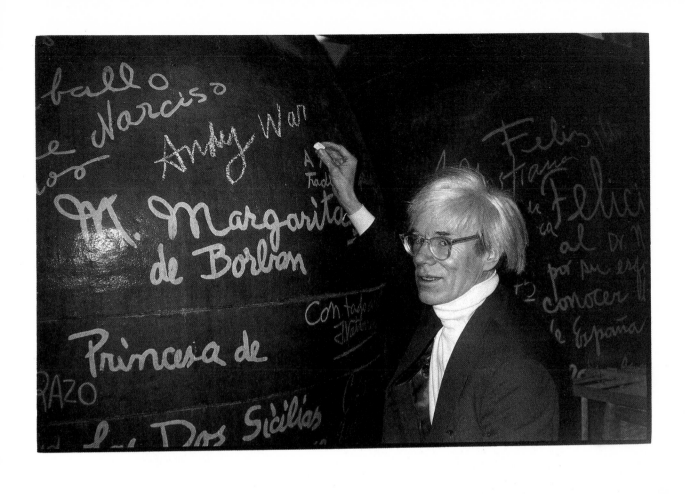

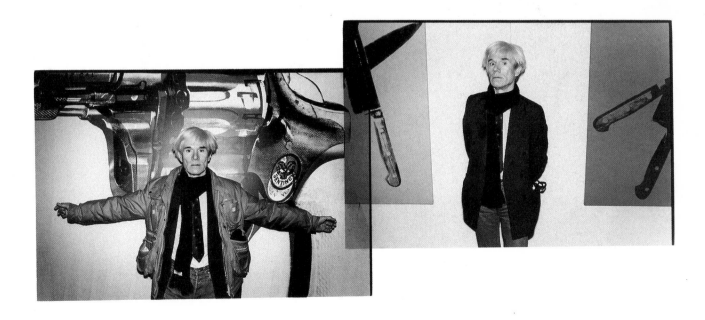

TOP Andy signing wine vats at the Las Cuevas del Vino restaurant in Chinchón, Spain. (January 1983)
BOTTOM In front of Andy's 'Guns and Knives' paintings at the Galleria Fernando Vijande. (January 1983)

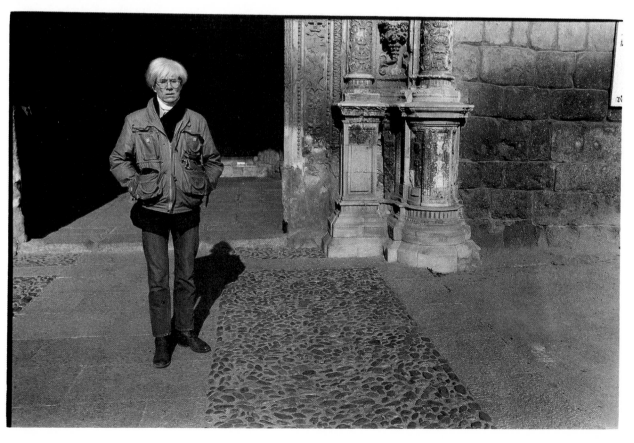

TOP AND BOTTOM Inside and outside the Hospital de la Santa Cruz, Toledo, Spain. (January 1983) 93

USA

With some bikers on the west-side highway of Greenwich Village, New York. (18 May 1981)

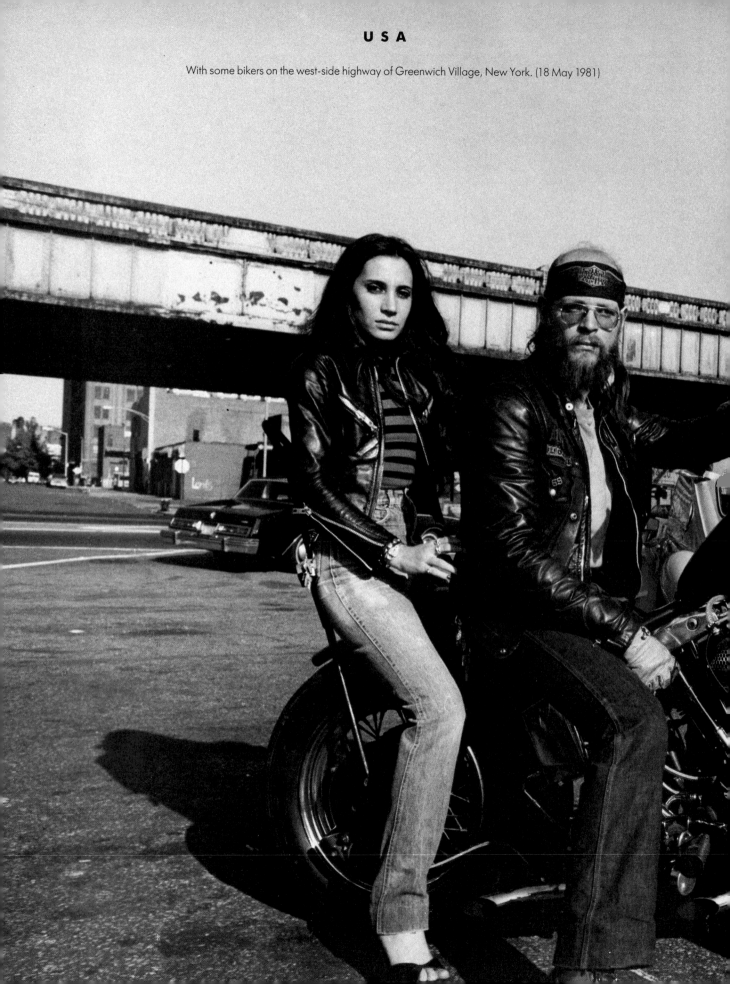

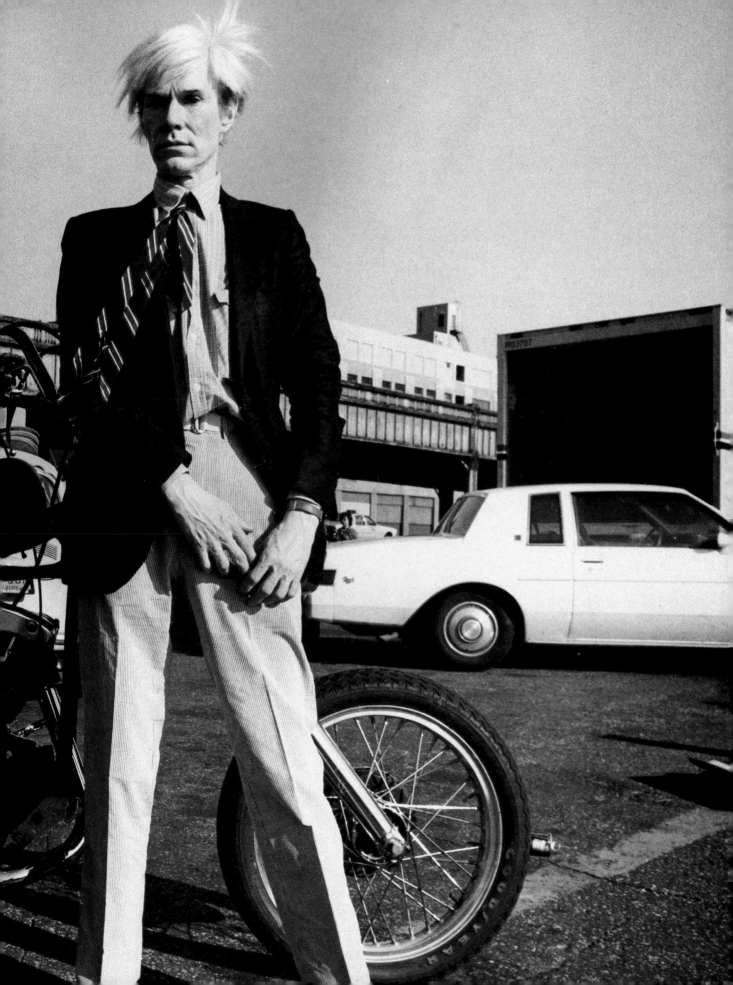

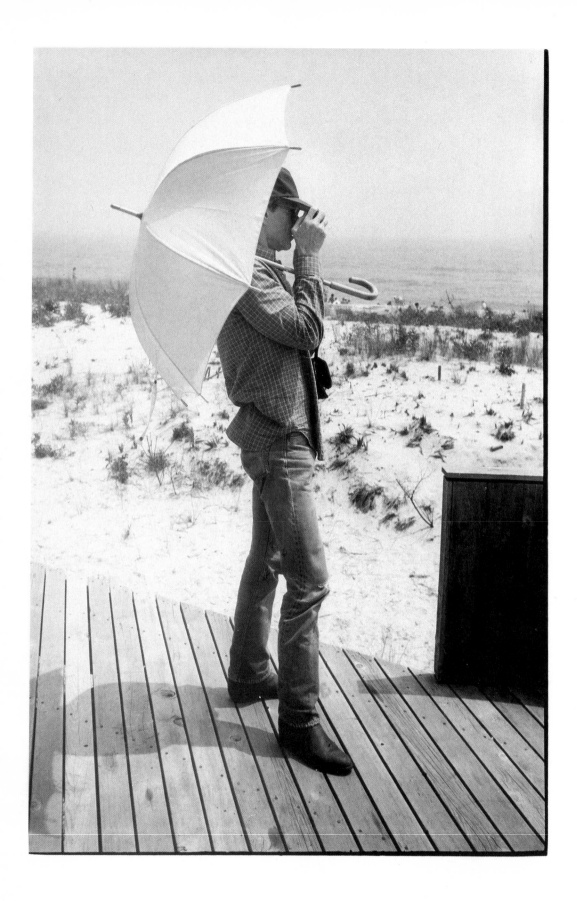

On the deck of Calvin Klein's beach house, Fire Island, New York. (16 August 1982)

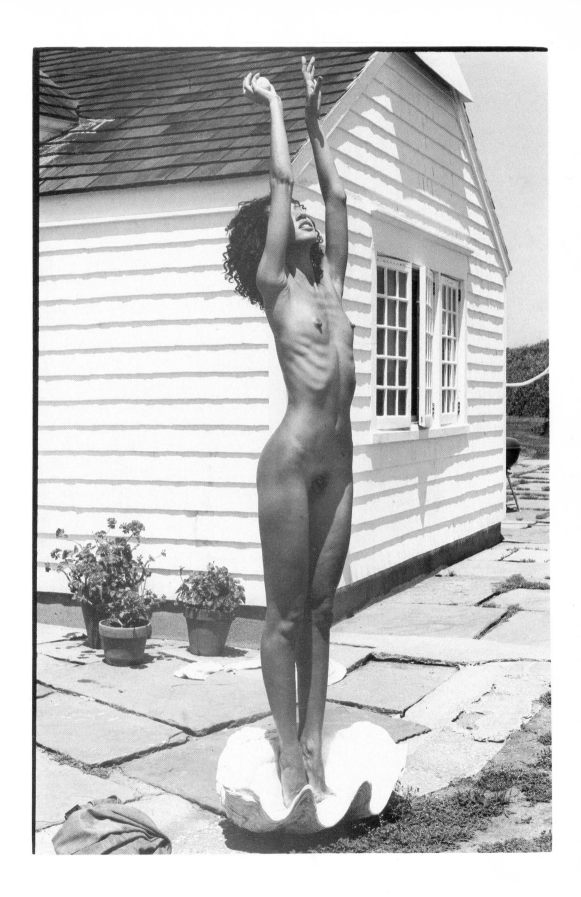

Photographing model Pat Cleveland at Andy's beach house in Montauk, New York. (15 July 1981)

liked was mashed potatoes. He had no qualms about going into a fancy restaurant and ordering mashed potatoes, carrots and herbal tea.

GERMANY

During a trip to Germany, for an opening of Andy's work in Düsseldorf, we stayed at a hotel that had two sections: one very old, the other modern. As the concierge showed us to our suites, he told us that we would be staying in the hotel's older wing because it would be of more interest to an artist. By the time he'd finished explaining this, we were standing before a set of huge iron gates, which then opened to reveal a pair of twin carved doors. On the other side of these doors was one of the suites: a damp room filled with chunky, dark furniture, with a window that looked out on to a courtyard drenched in the pouring rain. Andy said, 'We really can't stay here. We want the new section, the interior decorated rooms.' The concierge didn't understand our reaction — he must have thought we'd seen a ghost — but he immediately directed us to the new wing. Andy would have stayed there if he'd thought it would make the group happy, but he saw the look of horror on our faces. It was like Frankenstein's castle.

CHINA

China was the most exciting place I ever travelled to with Andy. Going to Paris or London with Andy was one thing, but the trip to China was the big equalizer. Most people didn't know who Andy was, which put pressure on him to be quite normal — even though the circumstances were a bit abnormal because he was being filmed for a documentary. We had an unbelievable flight on one of those tattered old China Airlines 707s. The trip was pretty low-key; the only people who recognized Andy were other American tourists. Of course, the Chinese always noticed him in a crowd, but mainly because he looked so unusual, not because he was the guy who painted those portraits of Mao.

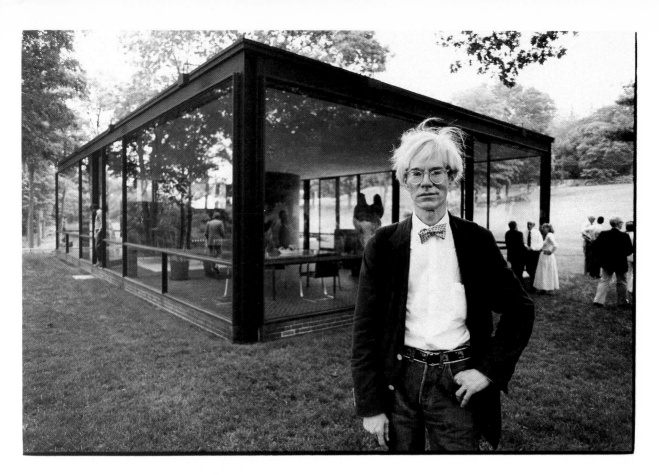

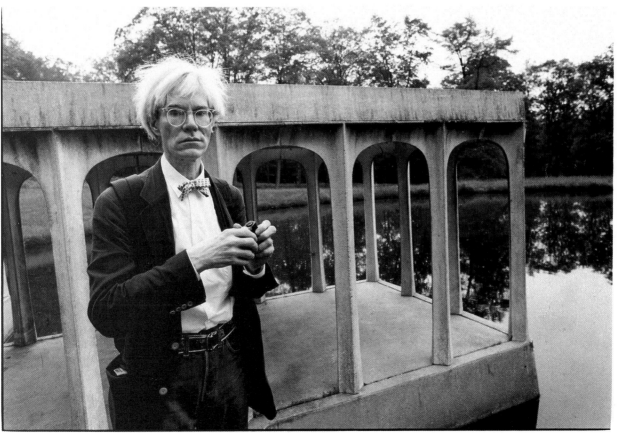

TOP In front of architect Phillip Johnson's glass house, New Canaan, Connecticut. (10 June 1981)
BOTTOM Posing by Phillip Johnson's folly. (10 June 1981)

When we got to the Great Wall, Andy looked up and said, 'Oh my God, I can't walk up that hill. It's too much work.' When I reminded him of the unique photo opportunity, he regained his strength. Besides, there was a film crew waiting at the Wall to photograph him.

The whole Chinese trip was a kind of Warholian experience. Andy loved seeing the masses of organized, clean, similar-looking people. Everywhere we went there were droves of blue or green outfits coming at us. All the bicycles the people rode were the same make. Andy didn't appreciate Chinese beauty, but he did appreciate the people's simplicity and their ant-like organization.

With about a thousand gifts stuffed into our luggage, we were about to leave for the airport, when Andy insisted that we go down to the street and buy some of a certain type of tartan red suitcase (costing about $2.99 each) from a street vendor. His idea was to empty the contents of our over-stuffed suitcases and repack them into these smaller, but more numerous, new suitcases. So our gang of four's suitcases multiplied from 5 to 28, and we duly arrived at the first-class check-in at Pan Am. The attendant stared at us in disbelief and pulled out a sheet of regulations, which explained in no uncertain terms that we would be heavily fined. A ridiculous and impossible scene ensued, and after 100 names of Pan Am bureaucracy had been jotted down and the entire waiting room thoroughly rattled, we were forced to pay a fine of about $1,000. Once again, Andy's fascination with multiples had led to drama; deep down he was relishing the practicality of the exercise and the visual impression our group would make on our arrival at US customs with 28 bags of exactly the same size and colour.

In Beijing, we had really gone out of our way to shop for unusual gifts to take home. Silk from all quarters of the city. After travelling with them for thousands of miles, we got back to New York, where Benjamin Liu, an assistant at Andy's studio, informed

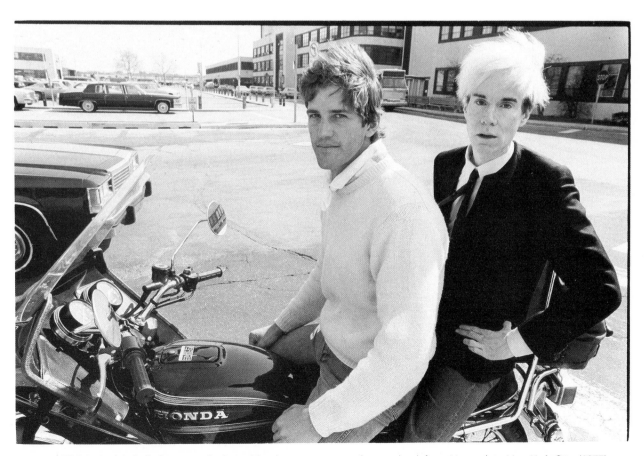

TOP In Andy's Rolls-Royce on the Long Island expressway, on the way back from Montauk to New York City. (1977)
BOTTOM With Perry Ellis model Matt Norklin at La Guardia airport while Andy was waiting to do his TV commercial for New York Air. (26 April 1982)

us that everything we had carted all the way back could be found downtown in Chinatown for maybe only a dollar or so more. That cast rather a shadow on the whole trip for a few hours.

ASPEN

We used to go to Aspen for the week after Christmas, and, while the rest of the group went skiing, Andy and I would go to the village of Aspen and buy everything that was on sale, until one year, when I just became sick of shopping. That was when I hired a professional skier to teach Andy. It was the first time he'd ever skied. First we went on the baby hill, with a rope and pulley, and then I made Andy go all the way to the top of Buttermilk Mountain, and he more or less snow-ploughed all the way down. He absolutely loved it, until the last hill, when he became exhausted and gave up. He didn't want to snow-plough any more: he was finished. So he just sat down and slid the rest of the way down the mountain — except that somehow he caught his Rolex watch on a branch. Then he started complaining in a big way. I said, 'Just get up, and stop complaining. We're going to make it down this hill. Now shut up.' And he said, 'It really hurts, it really hurts, Chris.' We finally got off the hill, and he really *was* hurt. We went to the hospital, and they announced that he had sprained his wrist. So Andy had a skiing injury, and his bandaged hand was like a badge. Everyone back in New York was thoroughly fascinated.

Andy wasn't exactly a sportsman, but he was game for just about anything if he could do it with friends. We went out on snowmobiles on the steep gorges in Aspen, and Andy nearly went over the edge of a cliff. He was wearing an enormous fur coat that Halston had given him for Christmas, and it made him look like some mad thing. It was embarrassing, but he loved it because it was from Halston. Actually, he loved it because it was wild.

ANDY'S PHOTOGRAPHS

On trips to Europe, he would often have portrait commissions lined up. For Andy, that meant getting out

the Polaroid. I did whatever I could to help out when I was around, which meant loading Polaroid film and changing flashbulbs. He'd take about 50 pictures, and I'd line them up on the table so that he and the subject could choose the best pose, the one that he'd blow up and paint. Andy would pick his favourites, and the clients would pick their favourites, and sometimes they'd agree and sometimes they wouldn't. When they didn't agree he'd look at the client's choice again and say, 'Oh, that's not so bad.' Being a good photographer had nothing to do with his art because as long as you had an image that felt right, that was all you needed. He could take care of the rest. He made attempts at working with more technically perfect cameras to get clearer images, but focusing them became a nuisance, so he'd always go back to the Polaroids. Besides, half of painting any portrait was about face-lifts and nose jobs. He had half a dozen stock lips that would appear from time to time. I don't know whether Mrs Düsseldorf knew she was getting Liza's lips, but they sure made her look better. The point was to make clients look glamorous. That was what they paid Goya for; that was what they paid Andy for.

Both Andy and I had small instant flash cameras; we learned a lot together. The first camera that Andy ever had was a Minox GL, which was the camera he used for all the pictures that appeared in his book *Exposures*. But using the Minox meant you had to adjust the focus, and he wasn't interested in that at all. That was where I came in with the auto-focus cameras.

The first one that I got myself, and that I got Andy interested in, was a Chinon, which was one of the first small, infra-red cameras available that can be used in dark places like clubs and restaurants. Once Andy began using auto-focus cameras he had the freedom to be really kooky. With an auto-focus camera you don't even have to look through it, you more or less just have to aim it, and that was what he did. It was a great personality gimmick for him, because now

he didn't have to talk to, or even look at, anyone for too long. It became an exciting thing when Andy showed up with his little camera and the flashes started to go off.

I was the art director on *Exposures*, and I also printed all Andy's photos for the book, so I saw the pictures through from start to finish. With that kind of responsibility I got to know everything about his photos and to 'see' as he did, as it were through his eyes. After a while, it got to the point when I didn't need to go to the dinners and parties with Andy any more — who wanted to, anyway, who cared?

They were gimmick photos, very offhand and sloppy, but that was because Andy was often in extraordinary situations. If you gave an auto-focus to a monkey and put President Reagan in the same room, you might get two pictures you could use, and that's all you'd need.

We never spoke of his photos as art. I mean, I would just ask him if he could try to focus better, use a little bit more care, and try actually to aim the thing once in a while. He definitely took more care after the publication of *Exposures*, because when the art dealer Bruno Bischofberger offered to turn his photos into portfolios, he began to take his pictures more seriously, as if to say, 'These are my art photos.'

SEWING MACHINE

The sewn photos were an idea I gave him. When I was growing up, my mother had a sewing machine in the house and I used to sew dollar bills and paper together, although I never thought of it as art then. I told Andy about it because I knew it would give him an opportunity to repeat images, which is something he was — and still is — known for. So I asked a friend of mine, Michelle Loud (from the Loud family of 'An American Family', the infamous PBS documentary), to come in and sew for Andy. A few years later, someone from the Robert Miller Gallery saw the sewn photos and gave Andy a show. On the night of the opening, I was moaning and groaning, and saying jokingly, 'Love

continued on Page 112

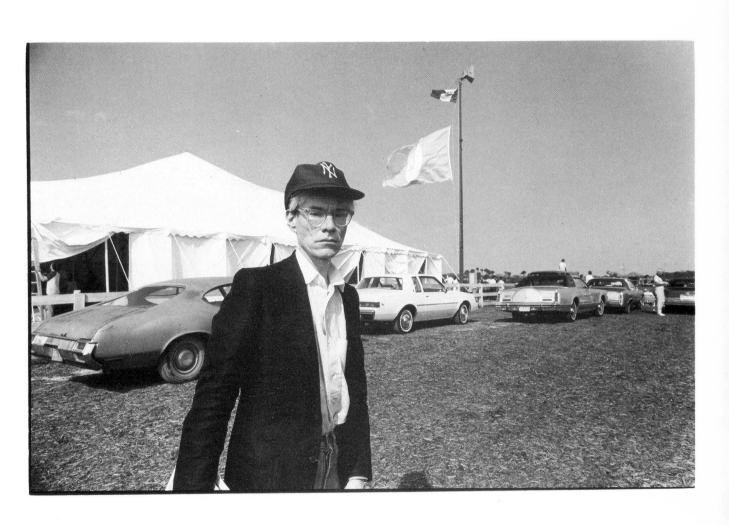

Passing by the press tent at the Palm Beach polo matches in Wellington, Florida, on his way to meet Cornelia Guest and Ralph Destino. (22 March 1982)

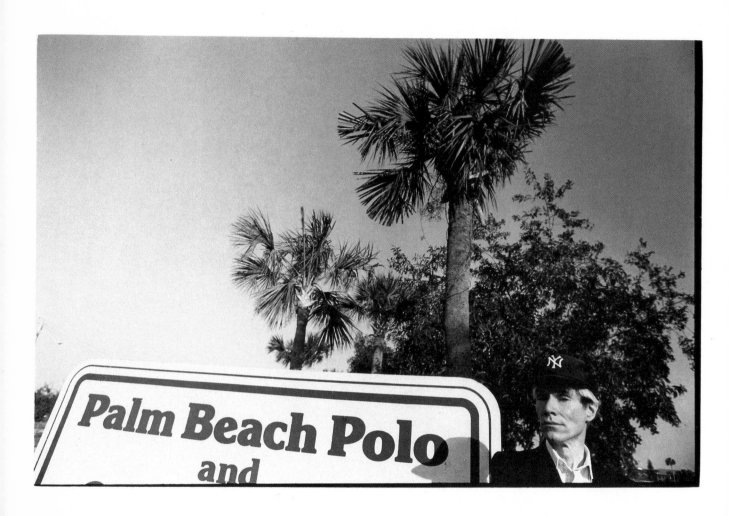

The sign reads: **Palm Beach Polo** and

Standing on swamp ground by the Palm Beach Polo sign. (22 March 1982)

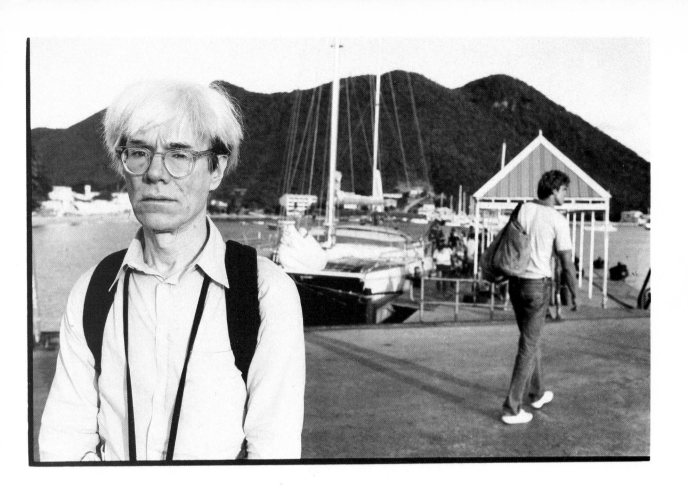

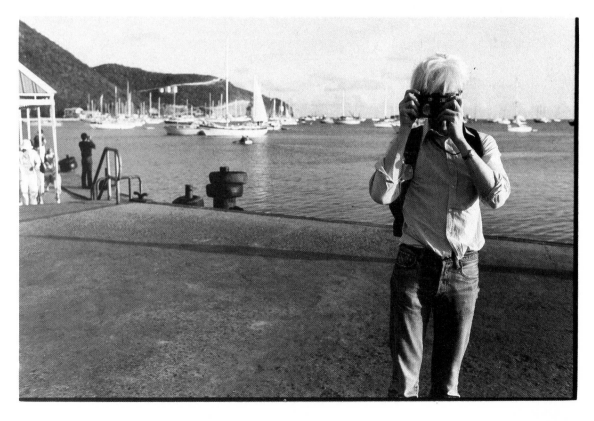

TOP Our first day on St Maarten, Virgin Islands. (19 April 1983)
BOTTOM Our second day on St Maarten, Virgin Islands. (20 April 1983)

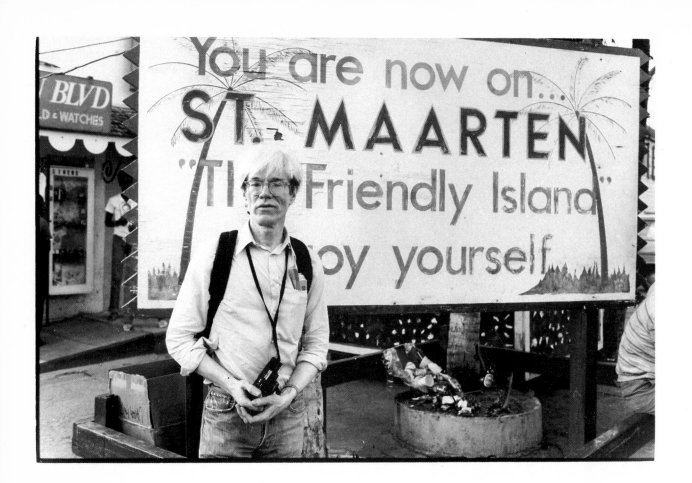

Getting ready to pose for a photo. (20 April 1983)

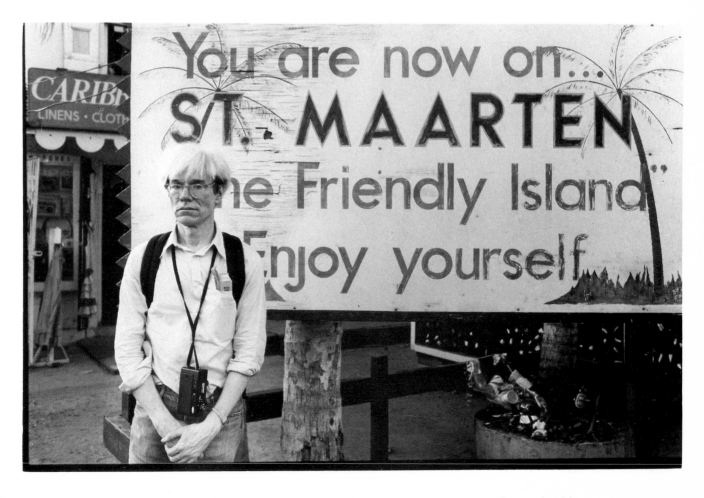

Andy giving one of his model looks while all ready and waiting to go back to La Sammana, the same hotel that Nixon stayed at. (20 April 1983)

TOP Posing by one of the many stuffed creatures that Andy kept around the Factory. (May 1981)
BOTTOM Finding out that his temperature was too high to take a trip to Seattle, Washington, where he wanted
to go to get a pearl. (4 October 1977)

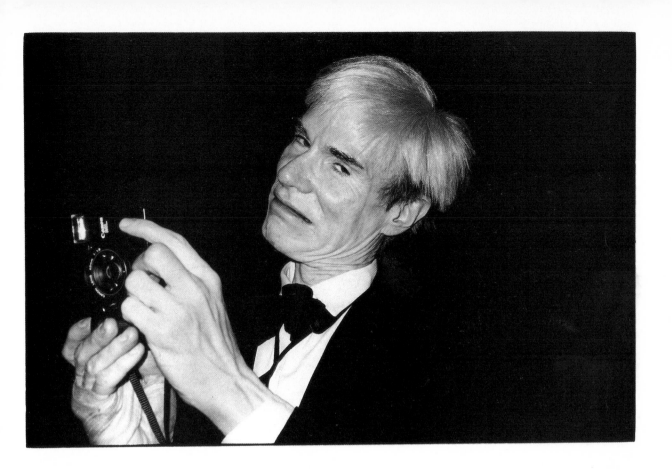

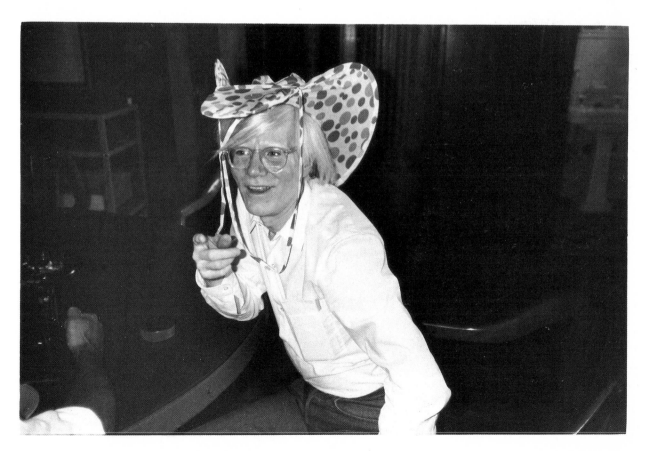

TOP Preparing his Chinon camera for a big party at Radio City Music Hall. (25 January 1982)
BOTTOM Experimenting with a folding hat at 860 Broadway. (7 November 1980)

your show, Andy.' And he said, 'Oh, Chris, thanks for the really great idea,' to Robert Miller or to anyone else who happened to be standing around, but he said it in a theatrical, off-putting sort of way so that no one would really believe it. Afterwards he went off to the big dinner party, and I went off to my own dinner, not a party. When I got home, there was a message on my answering machine from Andy, saying, 'Thanks Chris.' And that was it – it was a wonderful thing. I felt so flattered. Everything was perfect then.

AT HOME

No one ever really saw Andy's house, except his very closest friends. Fred, Jed Johnson (who decorated it), me, and a few others. He gave some incredibly lavish Christmas parties, but they were Christmas parties for four. He'd serve tins of Beluga caviare and champagne.

That's something those people at the Factory don't understand. They were Andy's *business* people – although Fred Hughes was very close to him, too. Fred has so much of Andy in him; Fred *was* Andy at times.

LEARNING

Through all my experiences with Andy I learned how to get in touch with myself, because I was around this guy who was a millionaire, a world-famous painter, film-maker, publisher, a celebrity – so he must have been doing something right. Because of my own impetuousness, I had always resisted set ways of doing things, and so I never really accepted anything Andy said as a message from above. That was why he and I got on so well together, because I wasn't just a fan. I didn't care that he was a famous pop artist; I used to confront him on every issue; I was a friend.

PHILOSOPHY

Both Andy and Man Ray, with whom I worked in the seventies, taught me the same thing: 'Don't think about making art, just get it done. Let everyone else decide whether it's good or bad, whether they love it or hate it. While they're deciding, make even more art.'

Pretending to ride my bicycle after leaving the Factory. (18 May 1981)

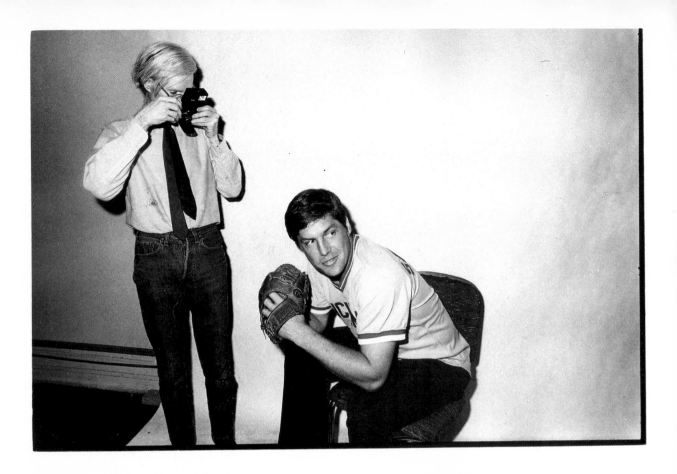

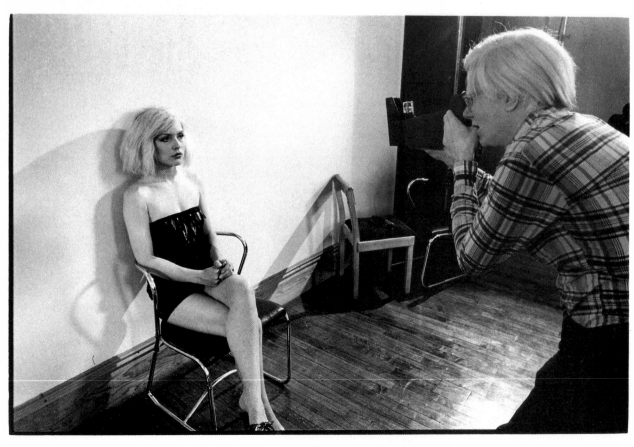

TOP Working on the Richard Weissman Sports Stars series, here with baseball star Tom Seaver. (20 July 1977)
BOTTOM Pop star Blondie, aka Debbie Harry, having her portrait done. (30 September 1980)

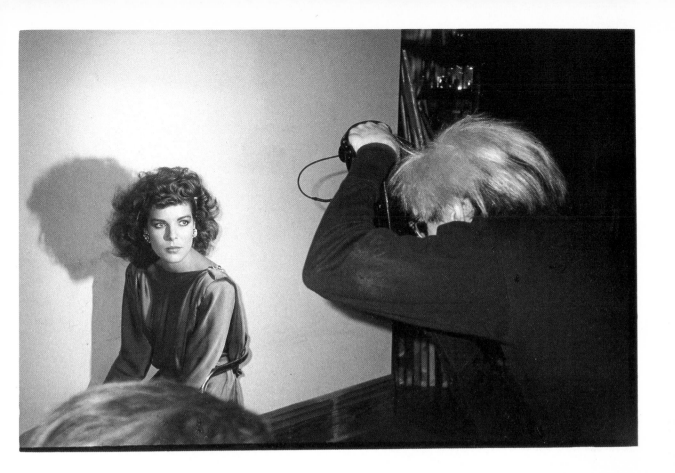

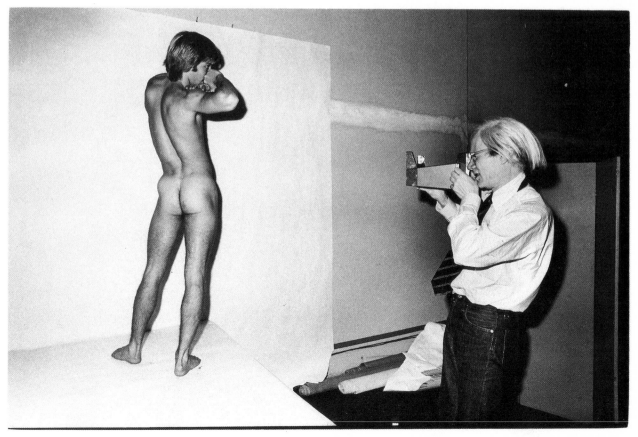

TOP Princess Caroline posing for a portrait for the cover of the French *Vogue* that she edited, *Vogue par Caroline*. (1982)
BOTTOM Californian Bobby Houston poses for Andy for a series called 'Sex Parts'. (9 June 1977)

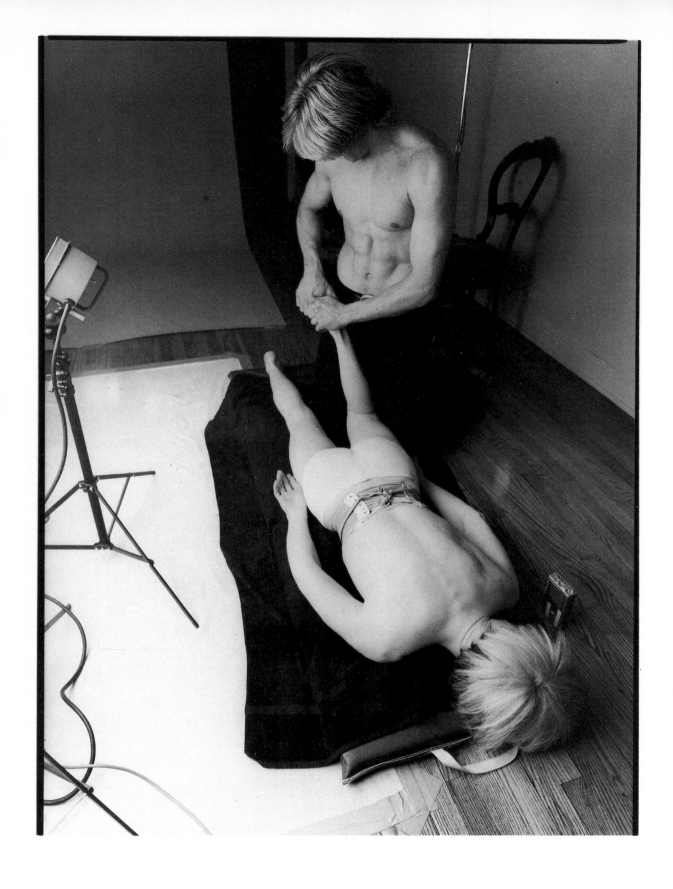

Getting a massage at my studio. His masseuse advocated that he eat several cloves of raw garlic a day, to cleanse his blood. His blood became just fine, but the aroma of garlic became quite an issue — and the Guerlain scents became quite helpful! (1983)

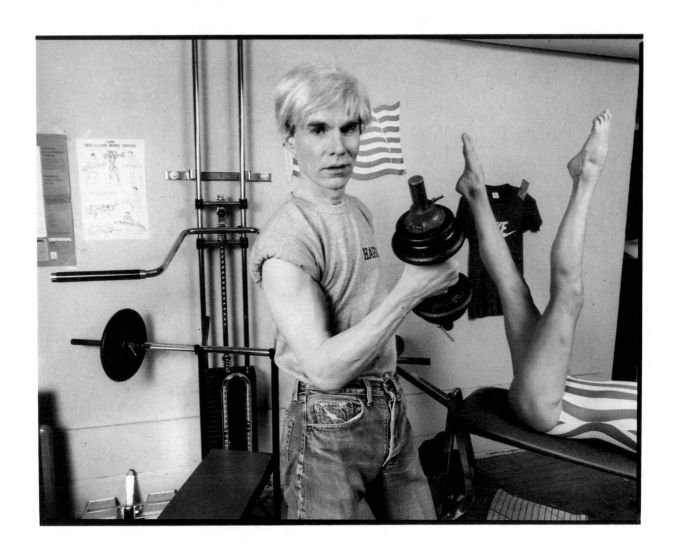

Working out with Soho Training Center owner, Lidija Cengic, at the Factory. (18 June 1982)

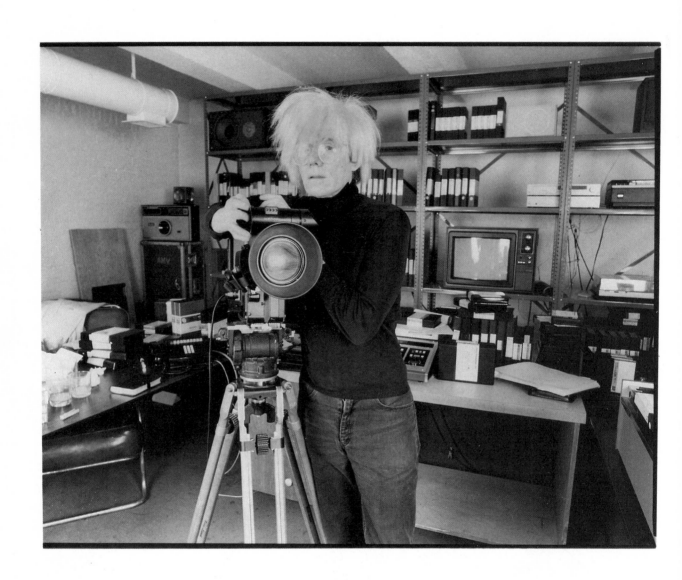

Posing for the cover of *New York Talk* magazine in Andy's video study on 33rd Street. (17 August 1985)

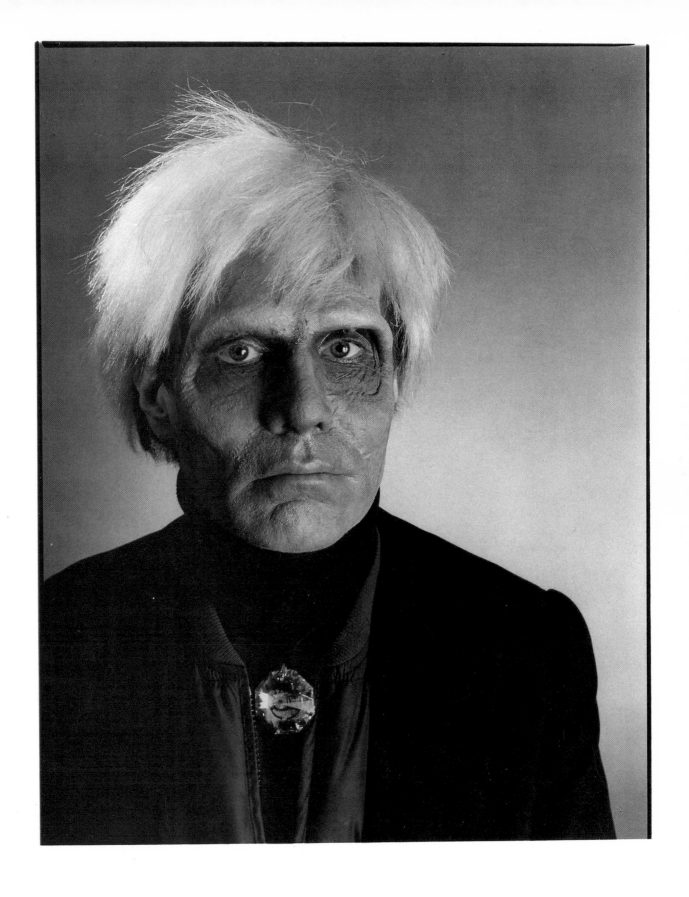

Made up as a zombie by horror-effects artist Tom Savini. Andy is wearing his crystal, which he rarely let himself be photographed with. (18 August 1985)

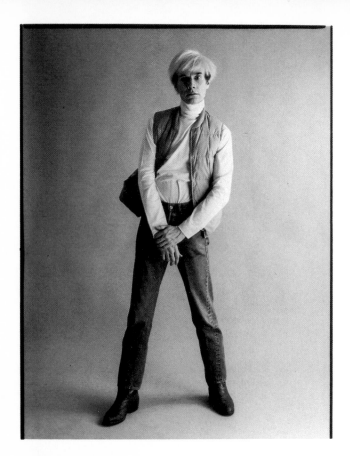
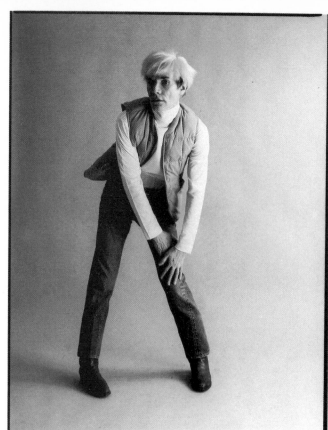
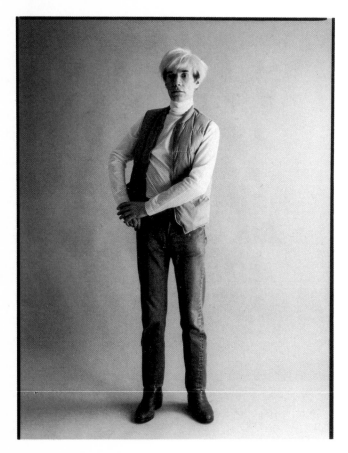
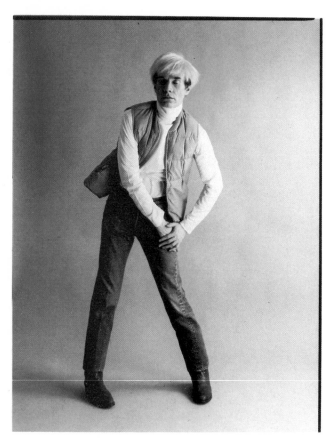

Practising posing at my studio, so as — hopefully — to get more modelling jobs through his then modelling agent, Zoli. (1983)

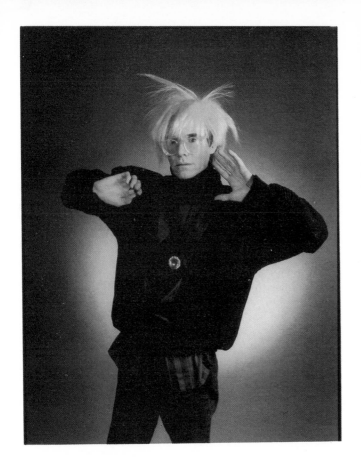

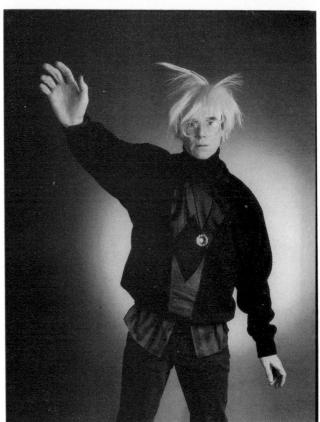

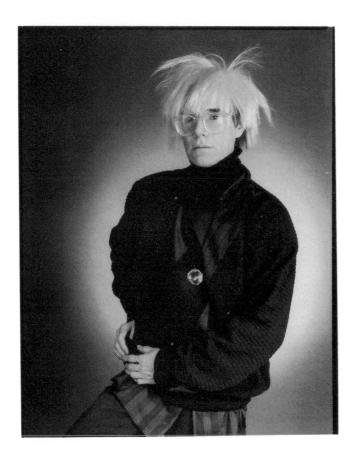

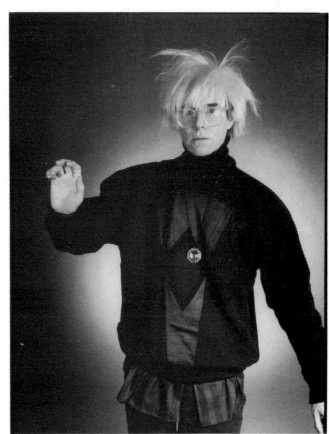

Modelling for the Italian men's fashion magazine *Linea Uomo*. (1986)

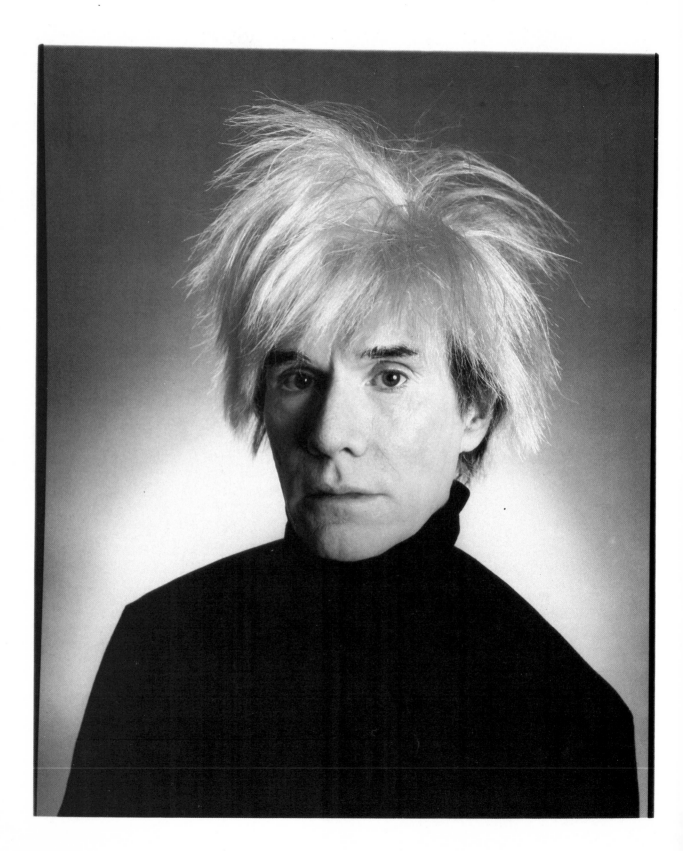

One of my favourite portraits of Andy . . . (1986)

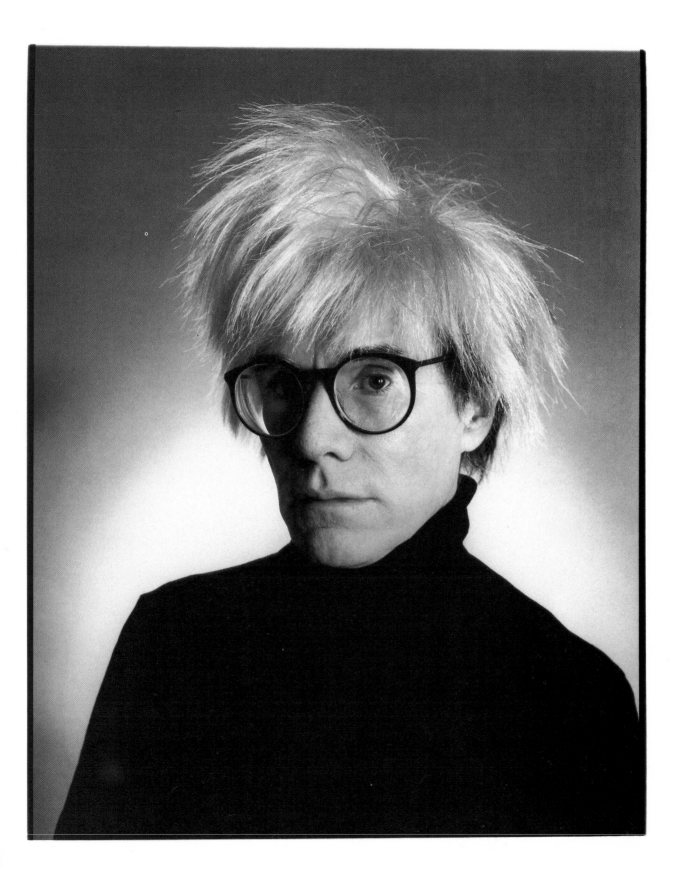

. . . and another. (1986)

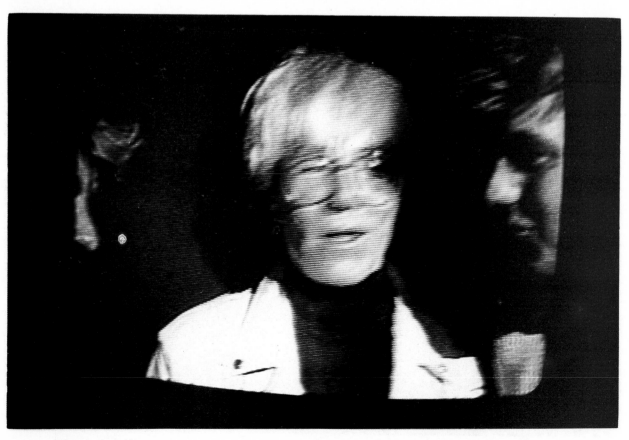

When Andy died I was on an assignment in Miami Beach, Florida. As I was picking up the key to my hotel room, the clerk asked me whether I knew that Andy Warhol had died in New York. I went to my room and switched on the TV. These pictures are the last time I saw Andy. (1987)

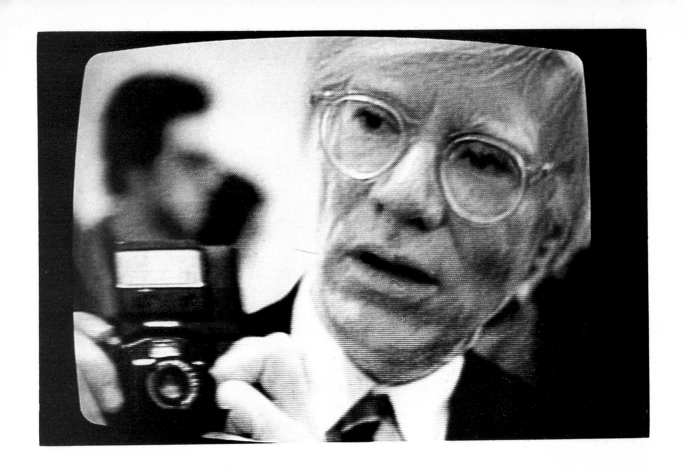

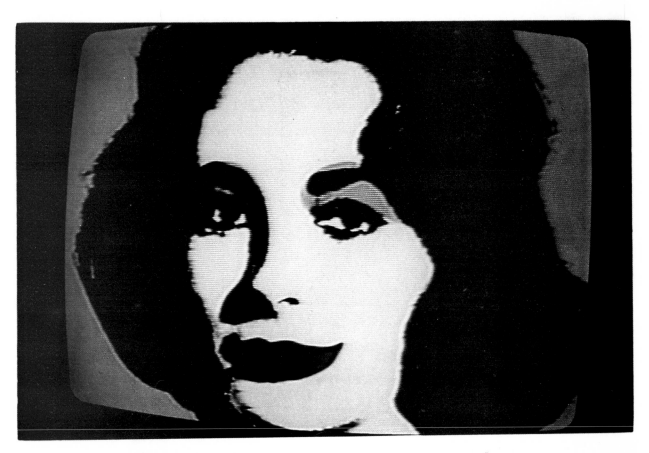

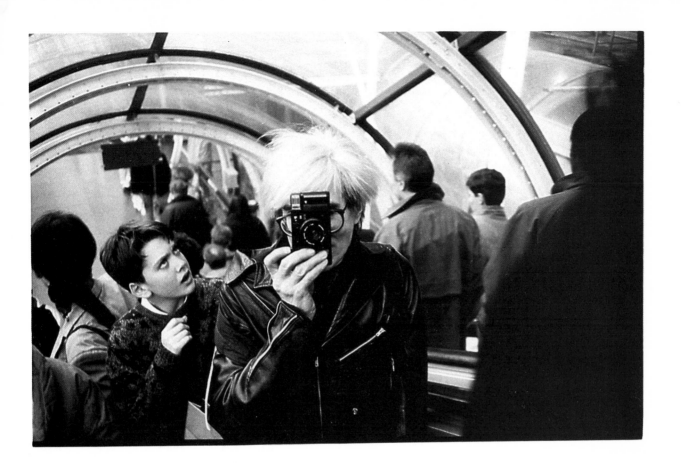

At the Beaubourg Museum in Paris, taking a shot of me, a shot of you! (1986)